DATE		

© THE BAKER & TAYLOR CO.

PLEASURE GROUNDS

Andrew Jackson Downing and Montgomery Place

with illustrations by Alexander Jackson Davis

PLEASURE GROUNDS

Andrew Jackson Downing and Montgomery Place

with illustrations by Alexander Jackson Davis

edited, with an introduction,
by Jacquetta M. Haley

Sleepy Hollow Press
Tarrytown, New York

Library of Congress Cataloging-in-Publication Data

Downing, A. J. (Andrew Jackson), 1815-1852.
 Pleasure grounds : Andrew Jackson Downing and Montgomery Place /
with illustrations by Alexander Jackson Davis; edited, with an
introduction, by Jacquetta M. Haley.
 Bibliography: p.
 Includes index.
 ISBN 0-912882-65-4
 1. Downing, A. J. (Andrew Jackson). 1815-1852. 2. Montgomery
Place (N.Y.) 3. Davis, Alexander Jackson, 1803-1892. 4. Landscape
architects—United States—Biography. 5. Architects—United States—
Biography. I. Davis, Alexander Jackson, 1803-1892. II. Haley,
Jacquetta M. III. Title.
SB470.D68A3 1988
712' 092' 4 — dc19
[B] 87-25968

First Printing.

For information, contact the publisher:
Sleepy Hollow Press
150 White Plains Road
Tarrytown, New York 10591

Sleepy Hollow Press is a division of Historic Hudson Valley (formerly Sleepy Hollow Restorations).

Manufactured in the United States of America.

CONTENTS

ANDREW JACKSON DOWNING
AND MONTGOMERY PLACE

Andrew Jackson Downing (1815-1852), America's first professional landscape gardener, engaged in a life-long love affair with the Hudson River and the great estates nestled on its eastern bank. Born and raised in Newburgh, New York, in the heart of the river's Highlands, Downing spent his childhood amid the natural beauties of the valley. At sixteen, Downing entered the family nursery business in Newburgh, then run by his elder brother Charles, and began his inspection of neighboring river estates, schooling himself in landscape design.

He acquired his theoretical background in the English or "natural" style of landscape gardening through the works of Humphrey Repton[1] and his great popularizer, John Claudius Loudon[2]. First-hand knowledge of the local Hudson River estates came through his partnership in the "C. and A.J. Downing" nursery at Newburgh. During these same years, artists, awakened to the aesthetic possibilities of the Hudson River landscape, began visiting Newburgh and other Hudson River communities. One of these artists, Raphael Hoyle[3], a young English landscape painter, taught Downing the elements of landscape composition which played so prominent a role in his ideas on landscape design.

This combination of theoretical principles, first-hand knowledge of plant materials and local gardens, and an artistic appreciation of the landscape as a whole, provided Downing with a vision of what America's largely rural landscape should

[1]Humphrey Repton (1752-1818), an English landscape gardener and architect, reintroduced the formal elements of the flower garden to the "natural" landscape design of the eighteenth century and promoted the adoption of architectural forms which "fit" their surrounding landscape. In his works, Repton attacked the use of classical architectural forms in rural landscapes and promoted the picturesque in design of both house and grounds.

[2]John Claudius Loudon (1783-1843) was a leading English proponent of Repton's "gardenesque" landscape style, one which appealed to the botonist and gardener as well as the landscape enthusiast. From 1804 until his death,

Loudon published numerous works on landscape design and gardening including massive encyclopedias of Agriculture; Architecture; Gardening; Plants; and Trees and Shrubs. His publications were directed toward the growing middle class and the needs of the increasingly literate working class.

[3]G.B. Tobey, *A History of Landscape Architecture, The Relationship of People to Environment* (New York: American Elsevier Publishing Co., Inc., 1973), p. 154. Raphael Hoyle (1804-1838), was born in England. He came to America early in the 1820s. He began exhibiting landscapes in 1828, and worked both in New York City and Newburgh in the 1830s.

look like. He spent the remainder of his short life articulating this vision of America in his immensely popular publications on rural landscaping and architecture.[4]

American gardens and architecture might rest on the principles of Repton and Loudon, but they had to be adapted to the American environment. Downing, in his role as educator of American taste, included vivid descriptions of the best in American landscape design in his works. He supplemented his richly textured prose with handsomely drawn woodcut illustrations. Alexander Jackson Davis (1803-1892),[5] prominent New York architect and talented watercolorist, became Downing's most frequent and successful collaborator for these illustrations. Together, Downing and Davis produced an image of rural America dominated by picturesque homes, great and small, each sited to take advantage of the natural beauties of its setting.

The estates fronting the Hudson River provided ideal illustrations of what Downing viewed as the best in American landscape gardening. They offered great variety in views and types of landscape encapsulated in relatively small estates —relative, that is, to those of Europe:

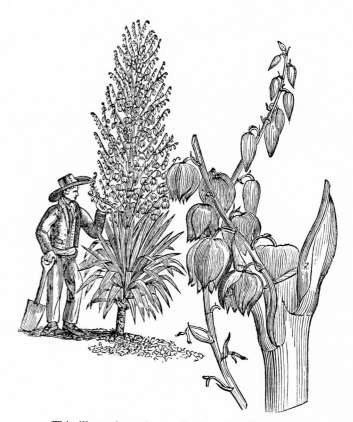

(This illustration, along with the other floral renderings in this chapter, originally appeared as accompaniments to various articles published in *The Horticulturist, and Journal of Rural Art and Rural Taste.*)

[4]A.J. Downing, *A Treatise on the Theory and Practice of Landscape Gardening, Adapted to North America; with a View to the Improvement of Country Residences* . . . (New York, 1841); A.J. Downing, *Cottage Residences; or a Series of Designs for Rural Cottages and Cottage Villas, and their Gardens and Grounds.* Adapted to North America. (New York, 1844); A.J. Downing, *The Architecture of Country Houses* . . . (New York, 1850); A.J. Downing, ed., *The Horticulturist, and Journal of Rural Art and Rural Taste,* (New York, 1846-1852).

[5]See biographical note on Alexander J. Davis, pp. 85-88.

There is no part of the Union where the taste in Landscape Gardening is so far advanced, as on the middle portion of the Hudson. The natural scenery is of the finest character, and places but a mile or two apart often possess, from the constantly varying forms of the water, shores, and distant hills, widely different kinds of home landscape and distant views. Standing in the grounds of some of the finest of these seats, the eye beholds only the soft foreground of smooth lawn, the rich groups of trees shutting out all neighboring tracts, the lake-like expanse of water, and, closing the distance, a fine range of wooded mountain. A residence here of but a hundred acres, so fortunately are these disposed by nature, seems to appropriate the whole scenery round, and to be a thousand in extent.[6]

Although the Hudson provided many examples of finely landscaped homes, Downing identified those on the eastern shore between Hyde Park and Hudson as the most significant:

The extent of the grounds, and their fine natural advantages of wood and lawn, combined with their grand and beautiful views, and the admirable manner in which these natural charms are heightened by art, place them far before any other residences in the United States in picturesque beauty.[7]

He selected one of these Hudson River estates, Montgomery Place, to illustrate the finest in existing American landscape design. At Montgomery Place, all the individual landscape elements came together to produce a whole "remarkable for its extent, for the wonderful variety of scenery—wood, water, and gardenesque—which it embraces, and for the excellent general keeping of the grounds."[8]

Montgomery Place, like most early-nineteenth century estates, started as a farm. Janet Livingston Montgomery (1743-1828), the widow of American Revolutionary War hero General Richard Montgomery (1738-1775), purchased John Van Benthuysen's 242-acre farm north of Rhinebeck, New York in 1802. With the help of her Irish nephew William Jones, Mrs. Montgomery set about building a mansion and shaping the landscape into an appropriate setting for her country home. Christened "Chateau de Montgomery,"

[6]A.J. Downing, *A Treatise on the Theory and Practice of Landscape Gardening, Adapted to North America; with a View to the Improvement of Country Residences . . .*, with Supplement by Henry Winthrop Sargent, 6th ed. (New York: A.O. Moore & Co., 1859), pp. 28-29.

[7]A.J. Downing, "Hints to Rural Improvers," *Rural Essays* (New York: G.P. Putnam & Co., 1853), p. 115.

[8]*Ibid.*

her new home provided ample room in which to indulge her "favorite subject Shrubs, Plants Flower & seeds[,] not forgetting Orranges [sic]."[9]

Mrs. Montgomery, raised at Clermont, the Livingston mansion a few miles to the north, brought a family love of plants and horticulture to her new home. Even as she began construction on her mansion she set up a commercial nursery, going into partnership with James McWilliams, "a shrewd Skotchman [sic] who will if any man can make his fortune." She also "commenced a correspondence with a person in England who will take from my Nursery all I have to part with...." Over the next fifteen years Janet Montgomery supplied her numerous siblings, their children and her neighbors, with seeds, bulbs, and fruit trees, just the items needed to beautify the surrounding countryside.[10]

Upon Janet's death in 1828, her youngest brother Edward Livingston (1764-1836) inherited "Chateau de Montgomery," changing the name to Montgomery Place. Edward shared his sister's love of plants. He also brought firsthand impressions

[9]Janet Montgomery to Edward Livingston, [March 23, 1804], Edward Livingston Papers: Published with permission of Princeton University Library, Princeton, New Jersey.

[10]Janet Montgomery to Edward Livingston, [March 23, 1804]; April 12, [1804]; Contract between Janet Montgomery and James McWilliams, April 14, 1804; Janet Montgomery Account Book, 1814-1818; Miscellaneous receipts; Edward Livingston Papers. Janet's nursery was undoubtedly one of the early competitors for the Downing family nursery in Newburgh. Samuel Downing, A.J. Downing's father, set up his nursery in Newburgh in 1801, three years before Janet began her project.

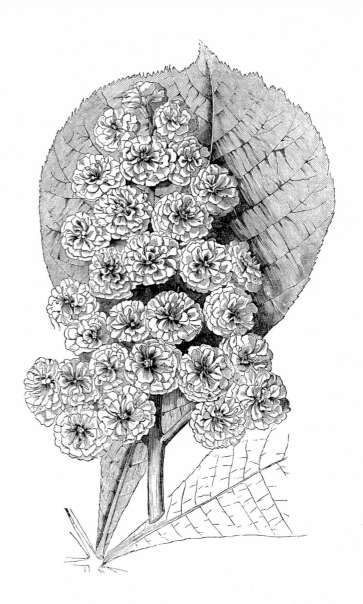

of the great gardens and estates of England and France to his country home on the shore of the Hudson. Despite his love of the property, Edward had little time to spend at Montgomery Place. His position as Secretary of State (1831-1833) under Andrew Jackson kept him in Washington for all but a month or two out of the year. Then he spent two years (1833-1835) in Europe as the United States Minister to France.

With his return to the United States in 1835 Edward finally had the opportunity to spend an extended period of time at Montgomery Place. Two years in Europe inspired him to begin an extensive reworking of the landscape: "We are all very well and very busy, planting, cutting down, leveling, sloping, opening views, clearing walks, and preparing much work for the ensuing spring to embellish." He rejoiced in his time at Montgomery Place, claiming it provided him with the "bliss of idleness in its perfection." By this he referred to "intellectual labor[,] for I have been extremely active in the improvement of my grounds, in the planting of trees and laying out gardens. When you return to stay at Montgomery Place you will scarcely know it again."[11] Edward's unexpected death in the spring of 1836 brought his planned improvements to a halt. Future work on Montgomery Place would be carried out under the direction of Edward's widow, Louise Livingston (1781-1860), and their only child, Cora Livingston Barton (1806-1873).

This was the state of affairs when Andrew Jackson Downing first became acquainted with Montgomery Place. In the first edition of *A Treatise on the Theory and Practice of Landscape Gardening* (1841), Downing referred to two old Livingston family estates near Barrytown which "owe almost their entire beauty to nature." Montgomery Place was undoubtedly one of these two estates.[12] It seems unlikely that Downing had visited Montgomery Place at this point. His praise was reserved for the beauty of its setting, rather than for the landscaping of the property itself. Downing knew the immediate neighborhood of Montgomery Place because of his landscape work at "Blithewood," Robert Donaldson's[13] estate immediately to the north. He had undoubtedly walked the common border of the two estates, the Saw Kill, a rambunctious millstream, and fully appreciated the glorious views of the Catskills. He also had access to printed sources such as Milbert's engraving "Lower Falls—Near the Residence of

[11]Edward Livingston to Henry Carleton, October 24, 1835; Edward Livingston to Auguste Davezac, December 16, 1835, Edward Livingston Papers. Henry Carleton was a prominent New Orleans resident, the husband of Edward Livingston's sister-in-law, Aglae Davezac Carleton. Auguste Davezac was Edward Livingston's brother-in-law and a frequent visitor to Montgomery Place. At this time he was the United States Chargé d'Affaires to the Hague and used the title Major.

[12]The second Livingston estate may have been Messina, the estate immediately south of Montgomery Place. Massena was built by John R. Livingston, another brother of Janet Livingston Montgomery and Edward Livingston.

[13]Robert Donaldson (1800-1872) was born in North Carolina and became a prominent New York City businessman. He built a succession of estates on the eastern shore of the Hudson during the second quarter of the nineteenth century. He was an ardent admirer of the picturesque style of architecture advocated by A.J. Downing and A.J. Davis and employed both men in designing the landscape and structures on his estates.

Mrs Montgomery,''[14] and an 1840 description of Montgomery Place that appeared in *The New-York Mirror.*[15]

Downing mentioned Montgomery Place by name in his second edition of *Landscape Gardening* (1844), making specific reference to recently added flower gardens and conservatory, to rustic seats and arbors. He had now visited Montgomery Place, probably following an introduction to Louise Livingston, its current owner, by either Robert Donaldson or architect Alexander Jackson Davis.[16] However, he still felt that Montgomery Place owed ''almost'' its ''entire beauty to nature,'' not to art.[17] Montgomery Place's newest owners were about to change that.

Following Edward Livingston's death, Montgomery Place went to his widow, Louise Davezac Livingston of Louisiana. Mrs. Livingston wintered with her daughter and son-in-law, Cora Livingston Barton and Thomas Pennant Barton (1803-1869), in Philadelphia, but they all spent the summer months at Montgomery Place. In 1844 Cora's growing interest in botany and horticulture led her to begin collecting books and magazines on landscaping and gardening. She ordered a complete backrun of Paxton's *Magazine of Botany*[18] with an ongoing subscription, and requested that her husband's London contacts search out ''some handsome work on *Rustic Architecture*/designs for summer houses/ Rustic hedges[,] Seats for lawns &c &c.'' The new works would be added to her current collection which included all of Loudon's works.[19]

The Bartons began planning major landscape work at Montgomery Place. A.J. Downing became involved in the subsequent blossoming of Montgomery Place in the latter half of the 1840s. He participated, however, as a friend and fellow lover of landscape gardening rather than as a landscape architect employed to reshape the grounds and vistas.

Downing's personal involvement with the new landscape plans began with a visit to Montgomery Place during the

[14]Jacques Gerard Milbert, *Picturesque Itinerary of the Hudson River and the Peripheral Parts of North America,* translated from the French and Annotated by Constance D. Sherman, (Ridgewood, N.J.: The Gregg Press, 1968).

[15]J.D.S., ''A Visit to Montgomery Place,'' *The New-York Mirror: A Weekly Journal of Literature and Fine Arts,* XVII, (February 8, 1840).

[16]Davis, with Downing, had worked extensively on Blithewood. Then, from 1841-1844 Davis worked with Louise Livingston on ambitious plans to enlarge and embellish Janet Montgomery's Federal-style house. During the summer of 1842 or 1843, Downing accompanied Davis to Montgomery Place on at least one occasion. Louise (Mrs. Edward) Livingston to A.J. Davis concerning Montgomery Place, [184-], courtesy of A. J. Davis Collection 2, Avery Architectural and Fine Arts Library, Columbia University (Avery 1-4).

[17]J.E. Spingarn, ''Henry Winthrop Sargent and the Early History of Landscape Gardening and Ornamental Horticulture in Dutchess County, New York,'' *Yearbook, Dutchess County Historical Society,* XXII (1937), p. 47.

[18]The *Magazine of Botany* was an English precursor to Downing's *The Horticulturist, and Journal of Rural Art and Rural Taste,* edited by English architect and ornamental gardener, Joseph Paxton (1801-1865).

[19]Thomas P. Barton to Thomas Rodd, January 29, 1844, Courtesy of the Trustees of the Boston Public Library, Boston, Massachusetts.

summer of 1845. Cora and Mrs. Livingston consulted with Downing on their proposed formal flower garden, one seemingly bewitched by an evil spirit:

> There seems to be some *evil enchanter* at work at your garden, *dwarfing* its dimensions every time it is measured. When Mrs Barton & myself measured it (carefully as I thought) it was 220 ft. Then Mrs. B. still more carefully made it *185 ft*—as I see by the note I took from her when she was here & which is still at hand, and now you tell me that you have only '124 ft.' I am glad to think this dwarfing process is confined to the limits of the flower garden or I should fear otherwise that the noble proportions of Montgomery Place would shrink to those of some paltry suburban cottage.[20]

Downing feared that the diminution of the proposed garden might spoil the chosen design, and suggested possible modifications to make the design more appropriate to its reduced scale. At the same time, he declared his "confidence in your and Mrs. Barton's judgement & taste," and his faith that plans "looked better after being executed than upon paper & [I] should be very sorry if this one in which I am so greatly interested should be an exception."[21]

[20]A.J. Downing to Mrs. Edward Livingston, October 28, 1845, Sleepy Hollow Restorations, Tarrytown, New York.

[21]*Ibid.*

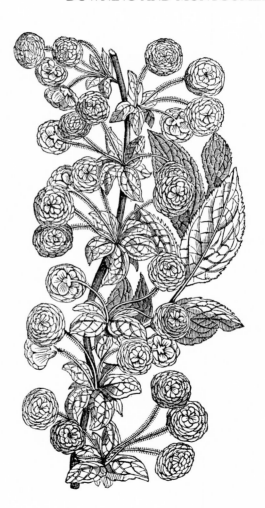

This is the only known instance in which Downing had a direct role in planning any part of the improvements at Montgomery Place. Even here, it is unlikely that his suggestions were formally submitted as a landscape architect. Rather, they were the informal suggestions of a knowledgeable friend. The tone of all surviving correspondence underscores this relationship.

Friendship did not preclude business dealings however. Downing, the nurseryman, certainly profited from the embellishment of Montgomery Place. Louise Livingston purchased $78.32 worth of flowering shrubs and ornamental trees from his Newburgh nursery during the fall of 1845. Here again, the tone of his correspondence is much more that of a friend than a purely business contact, with Downing bemoaning "something particularly unlucky about all the orders that are executed for Montgomery Place." Among the problems encountered that fall: trees shipped a week too early, shipments that just missed the barges to Barrytown, and raspberry canes left forgotten on the dock.[22]

From 1845 until his death in 1852, Downing remained continually informed of proposed improvements at Montgomery Place. His knowledge reflected the growing friendship between himself and Mr. and Mrs. Barton. Cora shared his intense interest in horticulture, while Thomas Barton became an avid enthusiast of arboriculture. Their shared interests led to frequent visits. Cora spent a day and night visiting Downing and his wife, Caroline, in Newburgh in September 1845, a return visit for several days that Downing had spent at Montgomery Place during the summer.[23] The Downings looked forward to summer invitations to Montgomery Place, "one of the most agreeable of the invitations of the season—we accept it with great pleasure."[24] They expected "impromptu" visits from the Bartons in return, offering on-going improvments at their own home as enticements:

> I have also been making some little improvements
> in my own garden—and especially building a rustic
> summer house which we call the "hermitage," and

[22]A.J. Downing to Mrs. Edward Livingston, October 21, 1845; Invoice, A.J. Downing & Co. to Mrs. Edward Livingston, October 14, 1845; Invoice, October 28, 1845; A.J. Downing to Mrs. Edward Livingston, n.d. [October/November 1845]; A.J. Downing to Mrs Edward Livingston, November 12, 1845, Sleepy Hollow Restorations.

[23]A.J. Downing to Major Davezac, January 8, 1846, Edward Livingston Papers. Major Davezac, Louise Livingston's brother Auguste, presented

copies of Downing's works to the Queen of the Netherlands. In return, she sent a note of appreciation and a gold ring to Downing. A.J. Downing to Major Davezac, July 30, 1845, Edward Livingston Papers.

[24]A.J. Downing to Mrs. Thomas Barton, June 17, 1848, Sleepy Hollow Restorations. See also A.J. Downing to Mrs. Thomas Barton, August 22, 1851, Sleepy Hollow Restorations.

which I think is so much in your own taste that I should be heartily glad to show it to you.[25]

Downing's interest in Montgomery Place took a literary turn in the summer of 1847. He had retired from the nursery business earlier that year, and now anticipated time to work on his books:

> I have sold out all my nursery interest, stock of trees, &c., and am rejoiced at the freedom from ten thousand details, and a very heavy business correspondence, of which I am relieved. I now shall devote my time to literary pursuits altogether, and my home grounds, as the nursery stock is gradually withdrawn, to experimental purposes—including a dash more of your favorite arboretum planting.[26]

One literary pursuit in particular proved most pressing. In 1846 Downing agreed to serve as editor for a new magazine

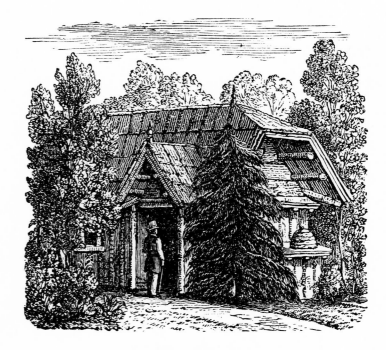

THE HERMITAGE.

[25]A.J. Downing to Mrs. Thomas Barton, June 13, 1848, Sleepy Hollow Restorations. In this instance, Downing refused to tell Cora anything about his ''hermitage,'' saying it was ''quite impossible to give any sketch or plan of the 'hermitage' until you see it!'' A.J. Downing to Mrs. Thomas Barton, June 17, 1848, Sleepy Hollow Restorations.

[26]A.J. Downing to John Jay Smith, February 19, 1847, ''Downing's Familiar Notes & Letters,'' *The Horticulturist, and Journal of Rural Art and Rural Taste,* XI (January 1856), p. 23. John Jay Smith (1798-1881) of Philadelphia, edited works on landscape gardening, rural architecture and American trees, and frequently contributed to *The Horticulturist* during Downing's lifetime. He served as editor of *The Horticulturist* from 1855 to 1860.

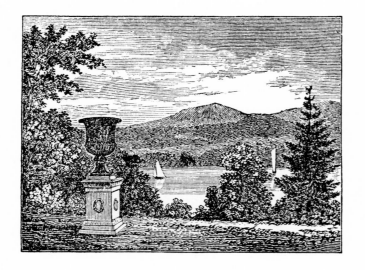

devoted to improving ''Rural Art and Rural Taste'' in America. *The Horticulturist, and Journal of Rural Art and Rural Taste* offered its readers helpful hints on garden design, appropriate styles for country cottages and outbuildings, plus the latest information on new plants and technologies available in the United States. Downing wrote monthly editorials which educated his readers on matters of taste as well as practical questions regarding life in the country. Through descriptions of exemplary American homes and gardens he hoped to encourage his readers to develop a uniquely American style in rural housing and landscaping.

In the October 1847 issue of *The Horticulturist*, Downing took his readers on an extended tour of Montgomery Place, an estate blessed with ''its varied mysteries of pleasure-grounds and lawns, wood and water.'' Following a brief and inaccurate account of the house's origins, in which he mistakenly attributed its construction to General Richard Montgomery[27], Downing described the setting, then explored ''The Morning Walk'' along the Hudson River, turned off into ''The Wilderness'' to the north of the mansion, and explored ''The Cataract'' and ''The Lake.'' Leaving the wooded walks on the northern border

[27]Richard Montgomery (1738-1775) was an Anglo-Irish soldier who moved to New York in 1772. He married Janet Livingston in 1773 and hoped to settle down to life as a gentleman farmer in Rhinebeck, New York. With the outbreak of hostilities in 1775, Montgomery was appointed a brigadier-general in the infant Continental Army. He led the unsuccessful charge on Quebec on New Year's Eve, 1775, where he was fatally wounded with a shot through the head.

of the estate, Downing then visited "The Flower Garden," Mrs. Barton's particular interest, and praised the conservatory designed by Frederick Catherwood[28] and built nine years earlier. He ended his tour with "The Drive" through fifty acres of oak wood on the southern border of the estate.[29]

Downing asked his long-time collaborator, Alexander Jackson Davis, to help him illustrate the glories of Montgomery Place.[30] Davis was already very familiar with the estate. From 1841-1844 he worked with Louise Livingston and Cora Livingston Barton to design a classically styled south wing, north pavilion, and west terrace for their Federal home. The landscape improvements begun in 1844 followed closely on the architectural improvements made during the previous years.

[28]Frederick Catherwood (1799-1854) was a London-born artist-architect who traveled extensively in Europe and the Near East before coming to New York in 1836. He set up as an architect in 1837 but his interest in archaeology led him to join John Lloyd Stephens on two tours of Central America. He and Stephens returned from Central America, having discovered the previously unknown ruins of the Mayan civilization. Catherwood is best remembered for his brilliantly executed drawings of these Mayan ruins.

[29]Downing condensed his description of Montgomery Place for his fourth edition of *A Treatise on the Theory and Practice of Landscape Gardening* . . . (1849), pp. 31-33, reusing the woodcut illustrations that had appeared with *The Horticulturist* article.

[30]A.J. Davis made many of the architectural renderings which appear in Downing's books, including the various editions of *A Treatise on the Theory and Practice of Landscape Gardening* . . . and *The Architecture of Country Houses*. . . (1850).

Davis spent July 21-28, 1847 in the Barrytown area. He stayed at Montgomery Place through the 23rd, then went on to Blithewood, Robert Donaldson's estate. He made numerous sketches of Montgomery Place, including "Island view of rustic temple on peninsula," "View of Pavilion, Montgom. place, looking up river," "View up river," and "View of Peninsula rustic temple for Mrs. Barton."[31]

Davis and Downing discussed exactly which views should be sketched, with Downing particularly interested in views of the river and the mountains beyond:

> I forgot to beg you before you leave Montgomery Place to sketch the view from the bold rustic seat with rustic balustrade in front* on the high west river walk. It seems to me one of the very finest things I have seen anywhere.
> *that seat about half way between the steps & the south terminus.[32]

During August Davis reworked four of these sketches on wood blocks as illustrations for Downing's article.[33]

With the publication of Downing's essay on Montgomery Place, the relationship between Downing and the Bartons clearly had settled into one of friendship, nurtured by shared interests. Downing sent Cora Barton a little basket of plants, but feared it approached sending "coal to New Castle," considering Cora's reputation as "an industrious collector." His gift included a new variety of gladiola, "just received from a friend in Ghent."[34] Later, he asked Cora to send him "those superb plants of the 'Triumph of Luxembourg' Rose (which I remember in your garden as I have seen them no where else)...."[35] Cora's reknown as a collector and gardener of significance received public affirmation in 1857 when a visitor to Montgomery Place described:

> an extensive flower-garden, the especial pet of Mrs. Barton, who has here shown effects which have not before been exhibited in this country. Her masses of roses and other flowers are particularly attractive. The arbors, overgrown with Aristolochia sipho, the Dutchman's pipe, exceed anything of the kind we have ever seen.[36]

[31]Alexander Jackson Davis, "Diary," 1827-September 1853, A.J. Davis Papers: Rare Books and Manuscripts Division, The New York Public Library (Astor, Lenox and Tilden Foundations).

[32]A.J. Downing to A.J. Davis, July 26, 1847, Kennedy Galleries, New York. [Current location unknown.]

[33]A.J. Davis, "Diary," 1827-September 1853, A.J. Davis Papers, NYPL. A.J. Downing to A.J. Davis, August 9, 1847, A.J. Davis Collection 2 (Avery 1-2). The original watercolor sketches for some of these illustrations

survive in a small sketchbook at the Franklin D. Roosevelt Library, Hyde Park, New York, and at the Avery Architectural Library, Columbia University.

[34]A.J. Downing to Mrs. Thomas Barton, June 13, 1848, Sleepy Hollow Restorations.

[35]A.J. Downing to Mrs. Thomas Barton, August 22, 1851, Sleepy Hollow Restorations.

[36]"Visits to Country Places," The Horticulturist, XII (January, 1857), p. 22.

Just as horticulture served as a common interest to bind Cora Barton and A.J. Downing, Thomas Barton's fascination with trees was shared by Downing. While Downing sent flowering plants to Cora, he sent information on the best London sources for rare trees to Thomas.[37] The need to keep Thomas Barton informed on sources of trees grew out of another project at Montgomery Place, one which ultimately involved Downing in public controversy. In the fall of 1846, Barton began work on his proposed arboretum, receiving the enthusiastic support of Downing:

> I am delighted to learn that you are about to add to the great charms of Montgomery Place by the formation of an arboretum. How few persons there are yet in this country who know any thing of the individual beauty of even our own forest trees! I wish you success in so laudable an undertaking.[38]

Downing's own interest in trees led him to plan a small arboretum on his own property in Newburgh and introduced a friendly rivalry into his correspondence with Barton. First, he felt he was uniquely suited to appreciate Barton's nascent

[37]A.J. Downing to Mrs. Thomas Barton, October 28, [1850], Sleepy Hollow Restorations.

[38]A.J. Downing to Thomas P. Barton, December 31, 1846, Sleepy Hollow Restorations.

arboretum: ''I think that I have imagination enough—being able to carry ten or twenty years *future growth* in my mind when seeing a plant only 1 ft. high—better than most persons—to be able to comprehend & enjoy it.''[39] At the same time, Downing believed his own efforts in the line of ''arboriculture'' were not totally insignificant. He hoped that ''possibly there may be some tree on my grounds that may have grown more respectable in Mr[.] Barton's eyes.''[40]

Downing's appreciation of trees led him to suggest a landscape architect to design the Montgomery Place arboretum, a suggestion that proved unwise. The efforts of the architect —his identity is unknown—were a failure.

After two years, Barton hired Hans Jacob Ehlers[41], a German landscape architect, to redesign the arboretum. Barton expressed initial satisfaction with Ehlers's efforts. That satisfaction soured when Barton refused to pay Ehlers's bill. Barton claimed that Ehlers's fee was even higher than Downing's, and Ehlers wasn't even an American. Ehlers responded by publishing a pamphlet in which he presented his professional qualifi-

[39]A.J. Downing to Mrs. Thomas Barton, June 17, 1848, Sleepy Hollow Restorations.

[40]A.J. Downing to Mrs. Thomas Barton, August 22, 1851, Sleepy Hollow Restorations.

[41]Hans Jacob Ehlers (c.1803-1858) was born in Schleswig-Holstein, trained as an arborist at the Kiel Academy and worked as a forester for the King of Denmark. He came to America between 1838 and 1842. Shortly after his

cations, defended his own actions and attacked both Barton and Downing. The pamphlet necessarily presents only Ehlers's side of the controversy, but he obviously felt cheated by Barton and insulted by Downing:

> In the spring of 1849, he [H.J. Ehlers] was engaged by Mr. T. Barton, of Montgomery Place, Dutchess County, to design and superintend the laying out of the grounds belonging to his country seat. An attempt had been made to do this by a person who had been recommended to Mr. Barton by Mr. Downing. The attempt had proved a complete failure. The work of two years had to be undone and begun anew. After the work was completed; Mr. Barton expressed himself satisfied with it. But although I charged him less than I considered my services worth, he has refused and still continues to refuse to pay more than about one half of my charge.[42]

Ehlers charged Barton ''only about $100'' for his work, which he felt was worth at least $200, ''under the persuasion that you would be highly pleased, and in accordance with your promise,

arrival, he laid out the grounds at Rokeby, an estate to the south of Montgomery Place. He died in Brooklyn. Spingarn, ''Henry Winthrop Sargent and the Early History of Landscape Gardening . . .,'' pp. 49-50.

[42]H.J. Ehlers, *Defence Against Abuse and Slander with Some Strictures on Mr. Downing's Book on Landscape Gardening* (New York: Wm. C. Bryant & Co., 1852), Introduction.

would recommend me to your friends.''[43] For this $100, Ehlers produced a rough plan for the Montgomery Place arboretum.[44]

The eventual resolution of this dispute is unknown. Nothing survives to tell us if Barton ever paid the balance of Ehlers's fee. Downing died tragically as a result of a fire aboard the steamer *Henry Clay* during the summer of 1852, before he could respond to Ehlers's attacks. Downing had boarded the *Henry Clay* at Newburgh, sailing for New York City. The *Henry Clay*'s steam boiler, overheated by an impromptu steamboat race, exploded. The passengers were forced to swim for shore. Downing drowned while trying to swim with a fellow passenger clinging to his back.[45]

The arboretum did survive. When Barton began his plantings, he expressed his hope that the arboretum ''will some day be worthy of notice.''[46] He received the notice he sought a decade later when Montgomery Place again received mention in *The Horticulturist*. John Jay Smith, the current editor and an enthusiastic arboriculturist, wrote:

> *Montgomery Place*, the seat of Mrs. Edward Livingston, and occupied by herself and her children,

[43]*Ibid.*, p. 6.

[44]H.J. Ehlers, Sketch of arboretum, Sleepy Hollow Restorations. At this time, Downing normally charged $20 a day for design work. ''Downing's Familiar Notes & Letters,'' *The Horticulturist,* XI (April, 1856), p. 161.

[45]For accounts of Downing's death see *The Horticulturist,* VII (September, 1852), p. 430.

[46]Thomas P. Barton to Thomas Rodd, November 3, 1848, Courtesy of the Trustees of the Boston Public Library.

Mr. and Mrs. T. P. Barton, was originally the residence of General Montgomery. It therefore has age and trees consequently of more antiquity than are usually seen. Its speciality now is the Arboretum, the most successful effort yet made among us, yet we cannot but regret that Mr. Barton has not allowed himself greater space for the future development of his various specimens, which, in process of time, must be seriously injured by their too close proximity. Nevertheless, *great* credit is due for this first effort.[47]

Additional praise for Barton's arboretum appeared two years later:

At Montgomery Place also, there has been planted within the past ten years, the most complete and satisfactory arboretum in the United States. Neither pains or expense have been spared in obtaining the most entire and thorough collection, or in the peculiar and appropriate preparation of the soil for the reception of the different varieties.[48]

In his correspondence with Mrs. Livingston and the Bartons, Andrew Jackson Downing repeatedly expressed his desire to help: "I shall always be most happy to be of the slightest

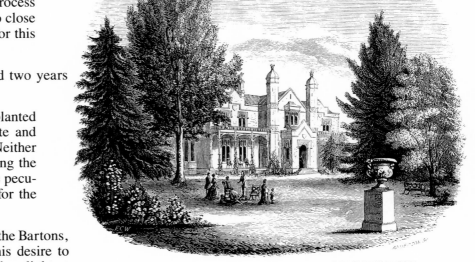

RESIDENCE OF THE LATE A.J. DOWNING, NEWBURGH ON THE HUDSON.

[47]"Visits to Country Places," *The Horticulturist*, XII (January, 1857), p. 22.

[48]Downing, *A Treatise on the Theory and Practice of Landscape Gardening*, 6th ed., p. 553.

service in your improvements.'' That help could take many forms: providing new and unusual plants for the garden, suggesting sources for trees and shrubs, planning a flower garden, or including a quick sketch of a ''propagating pit'' in a letter.[49] Although this willingness to help grew in part from his friendship with the Bartons, it also reflected his pride in Montgomery Place as an American model of rural art and gardens at their best: ''I assure you I take as lively an interest in Montgomery Place and feel as proud of it as belonging to this part of the world as I do of the Hudson itself.''[50] Even his trip to England in 1850[51] could not lessen his appreciation of Montgomery Place:

> I assure you I have too much pride and pleasure in the Hudson & too much affection for Montgomery Place to allow the possibility of any diminution of interest in all that belongs to it—because I have had the gratification of seeing the fine places of England.[52]

[49]A.J. Downing to Mrs. Thomas P. Barton, June 13, 1848, June 17, 1848, August 22, 1851, Sleepy Hollow Restorations.

[50]A.J. Downing to Mrs. Thomas P. Barton, June 17, 1848, Sleepy Hollow Restorations.

[51]Downing traveled to England in 1850 searching for a young architect to join him in partnership in New York. Calvert Vaux, future partner of Frederick Olmsted, returned to New York with Downing in this capacity.

[52]A.J. Downing to Cora Livingston Barton, October 28, [1850], Sleepy Hollow Restorations.

The following reprint of Andrew Jackson Downing's "A Visit to Montgomery Place," complete with Alexander Jackson Davis's original woodcut illustrations, gives the twentieth-century reader a vivid example of the best in mid-nineteenth century American landscape design. In addition, the publication of all the surviving correspondence between Downing and Louise Livingston, Cora L. Barton and Thomas P. Barton provides further insight into the relationship between Downing as the articulator of American taste, and the owners of Montgomery Place. Fourteen Alexander Jackson Davis sketches and plans for Montgomery Place are also presented for the first time. Several of these were preliminary sketches for the four illustrations which appeared in Downing's *Horticulturist* article. Other views, not used by Downing, provide additional evidence of the beauty of this mid-nineteenth century estate. Three plans for proposed garden and rustic structures show how Davis and the Bartons interpreted Downing's strictures on the correct use of architectural and rustic forms in landscape seats.

Andrew Jackson Downing's article, his correspondence with the Bartons, and Alexander Jackson Davis's sketches provide us with an intimate glimpse of the forces which shaped American landscape design in the mid-nineteenth century. Montgomery Place was important to Downing because it represented the best in European concepts of landscape design adapted to the American environment. The illustrated description of his visit to Montgomery Place which appeared in *The Horticulturist* gave nineteenth-century Americans a native example of what they should strive for in their own homes and gardens. Few could hope to equal the scale of Montgomery Place. They could, however, become sensitive to the all important relationship between art and nature, between the individual components of the landscape and the whole. It was here that Montgomery Place excelled.

Jacquetta M. Haley

ANDREW JACKSON DOWNING'S CORRESPONDENCE
REGARDING MONTGOMERY PLACE[53]

Letter #1
A.J. Downing to Louise Livingston

Highland Gardens
Newburgh Oct 21st 1845

Dear Madam

Herewith I beg leave to forward the invoice of the trees and plants forwarded you last week.

I regret more than I can express that there should have been any mistake in sending the trees & plants before you wished them. It arose solely from the time fixed in *your letter* which is now before me & which says "Tuesday the *14*th of Oct". You need however be under no apprehensions respecting the success of the trees; they will succeed quite as perfectly as if planted ten days later—indeed I am greatly in favour of planting the more tender trees & shrubs quite *early* in the autumn. All that I regretted at the time was that it was not quite so convenient for *us* to dig & pack them last week as now—not then having all our arrangements for transplanting complete—but that was a matter of small moments.

I would advise you to hill up the earth six or eight inches around the base of each tree transplanted this fall—to be removed in the spring.

The fruit trees shall be sent as you desire—early in

November by the Barge from New York and I will advise you previously of their shipment. Very sincerely your obt Servant

Mrs. Livingston A.J. Downing
P.S. We did not pay the *freight*.

[INVOICE ATTACHED]
Highland Gardens
Newburgh, N.Y. Oct. 14th 1845

Mrs. Edwd Livingston Bought of A.J. Downing & Co.

1 Willow Oak	6/	.75
1 large osage orange	6/	.75
3 American Cypress	$2 (extra size)	6.00
4 European Larch	4/	2.00
2 Liquidambar	4/	1.00
1 Coffee tree		.50
2 Silver aspen	4/	1.00
2 Scotch Elms	4/	1.00
2 Ash leaved Maple	extra size 8/	2.00

[53]These documents are owned by Sleepy Hollow Restorations, Tarrytown, New York. The transcriptions which follow are literal. Any editorial additions or changes are clearly indicated by brackets.

1 Three Thorned Acacia		.50
2 Western Magnolia 8/		2.00
2 Female Paper Mulberry 6/		1.50
1 Groundsel tree		.50
2 Strawberry tree large 8/		2.00
2 Sloe 4/		1.00
2 Barberry 3/		.75
2 large fruited Missouri Currant 3/		.75
1 Silver Bell		.50
2 Buffalo Berry 4/		1.00
2 Scarlet fl.g Quince 4/		1.00
2 White do 4/		1.00
1 Broad leaved Laburnum		.50
1 Cornelian Cherry		.50
2 English Fly (tree Honeysuckle) 4/		1.00
1 Privet		.50
18 Herbaceous plants 20 cts		3.60
Packing 5 large bdls & 1 box 6/		3.75
		$37.35

Letter #2
A.J. Downing to Louise Livingston

[October 28, 1845]
Dear Madam,

We have sent this morning by the Troy two bundles containing the shrubs ordered—the largest we have of the sorts—and trust they will reach you safely.

There seems to be some *evil enchanter* at work at your garden, *dwarfing* its dimensions every time it is measured. When Mrs Barton & myself measured it (carefully as I thought) it was 220 ft. Then Mrs. B. still more carefully made it *185 ft*—as I see by the note I took from her when she was here & which is still at hand. And now you tell me that you have only ''124 ft.'' I am glad to think this dwarfing process is confined to the limits of the flower garden or I should fear otherwise that the noble proportions of Montgomery Place would shrink to those of some paltry suburban cottage.

Seriously, I hope there is still room enough not to spoil the design entirely. I regret that we were not aware how limited you considered it necessary to make it as it might have been well to adopt some smaller design. As it is I should think that you would find it advisable to omit the narrow walks in the [———] in the large plots of the second plan—as they would scarcely be needed. But I have still for all these difficulties the greatest confidence in your and Mrs. Bartons judgement & taste. I have usually found that a plan looked better after being executed than upon paper & should be very sorry if this one in which I am so greatly interested should be an exception.

Mrs. Downing begs to be kindly remembered.
Very truly your ob^t servant
A.J. Downing

Mrs. Livingston
Tuesday 28th

[INVOICE ATTACHED]

Highland Gardens. Newburgh, N. Y.
October 28 1845

Mrs. Edward Livingston Bought of A.J. Downing & Co.

2 Barberry	3/	.75
2 Laburnum	4/	1.00
2 Dbl Scarlet Thorn	4/	1.00
2 Japan Globe Flower	3/	.75
2 Privet	4/	1.00
2 Rose Acacia	3/	.75
2 White Lilac	3/	.75
2 Strawberry tree	4/	1.00
2 Dbl. Pink Althea	3/	.75
1 Groundsel tree		.50
1 Large Siberian Lilac		.50
2 White Persian do.	4/	1.00
Packg 2 bdls	4/	1.00
Freight Paid	8/	1.00
		$11.75

Letter #3
A.J. Downing to Louise Livingston
[Oct/Nov. 1845]
Dear Madam
 There seems to be something particularly unlucky about all the orders that we execute for Montgomery Place. I trust the *success* of the trees when planted will make up for it.

 Your letter (as I advised you yesterday) came too late for the Troy on Thursday. The trees were ready for the Niagara to day but were not taken on board. We shall however endeavor to send them by the Troy tomorrow.

 You will see that I have used the liberty you gave me to vary your list. I have done the very best that the nursery would allow for size &c.
 Yours Very Respectfully (in haste)
 A.J. Downing
Mrs. Livingston

[INVOICE ATTACHED]

4 Trees:

1 Willow oa[k]		1.00
2 Osage Orange	8/	2.00
1 Madeira nut		1.00
2 Liquidambar	4/	1.00

Shrubs:

2 Purple Strawberry tree		
2 Red do do	5 at 4/	2.50
1 White do do		
2 Privet	4/	1.00
2 Tree Honeysuckles	3/	.75
2 large Scotch Roses	6/	1.50

PLEASURE GROUNDS

2 Ptelea or Hop Tree	4/	1.00
2 Silver Bell	6/	1.50
1 English Maple	4/	1.00
1 Broad leaved Laburnum		.50
2 Siberian Spirea	4/	1.00
2 White Lilac	4/	1.00
1 Cornish elm (rare- pretty habit)		.50
		$16.75
Packing 3 large bdls	5/	1.87
		$18.62
Freight—paid		1.50
		$20.12

Letter #4
A.J. Downing to Louise Livingston

Highland Gardens
Newburgh, N.Y. Novem 12th 1845

Mrs Edwd Livingston Bought of A.J. Downing & Co.

2 Apricots on Plum	4/	1.00
2 Nectarine do		1.00
4 choice selected Cherry 40cts		1.60
6 " " Peach	2/	1.50
8 " " Pear	3/	3.00
1 bdl. packing		.50
Freight paid		.50
		$9.10

Dear Madam

We are so exceedingly crowded with business at this season of the year that we cannot always take up an order at any moment—sometimes on the contrary it has to wait for several days. We were not able therefore to send the above to town so as to be put on board the ''Barge'' as you wished—but send them this evening by the Hudson boat which will land them at Barrytown. All the trees for Barrytown ought indeed to go in the way you desired the last—by the barge from N.Y—because the day boats dislike to take them. The last package previously, that we sent you we were obliged to send by the Hudson boat. We send all parcels to N.Y. freight free, and the cost of freight to you is therefore not increased.

The demand for pears has been so very great that we were out of all ''good sized'' trees of the sorts you wanted & I have therefore taken the liberty of selecting 8 for you. The Raspberries were overlooked till the parcel was gone but shall be remembered hereafter.

You may if you please remit us the amount of the several bills by mail—at our risk. If you could send it in the form of a check payable at yr bank it would be a more perfect way. Hoping the trees will arrive safely. I am with great respect your obedient servant
A.J. Downing
P.S. I hope in a day or two to be able to answer Mrs Bartons kind letter.

Letter #5
A.J. Downing to Thomas P. Barton

Highland Gardens
Newburgh Dec 31: 1846

Dear Sir

You will observe that I have taken the "days of grace" which in your letter you kindly allowed me for a reply. In truth I have had so many matters of business forced upon me lately that I have had less leisure for my correspondence than usual.

I enclose the list with the height and prices of all that we can furnish good specimens of in the spring. If you are ready to plant more I would advise you at some time during the winter to look through the nurseries of Landreth & Fulton below Philadelphia. I understand they have some fine and rare ornamental trees.

I beg you to present my kind regards to Mrs. Barton & say that I not only sent Major Davezac two large plants of the Night-smelling jasmine but also two plants of the "*Torreya taxifolia*" a new & beautiful evergreen tree —in habit between our Hemlock & the Yew—which has been discovered in Florida where it grows 50 ft. high. I believe there have been no specimens before these sent to the Continent of Europe. I also forwarded through my London publishers a copy of the Horticulturist up to this month—all of which I trust will reach Major Davezac safely.

I am delighted to learn that you are about to add to the great charms of Montgomery Place by the formation of an arboretum. How few persons there are yet in this country who know any thing of the individual beauty of even our own forest trees! I wish you success in so laudable an undertaking.

Mrs. Downing desires to join me in remembrances to Mrs. Barton & yourself & I remain
Dear Sir your most ob.^t Servant
A.J. Downing

Letter #6
A.J. Downing to Cora L. Barton

Highland Garden
Newburgh June 13: '48
My dear Mrs Barton

I send you in this little basket a few plants, which, as you are an industrious collector, *may* be "coal to New Castle." At any rate please accept them. The *Gladiolus Gandavensis* (of which I send 6 bulbs just received from a friend at Ghent) is the most exquisite of all its genus & will thrive in the open border in summer with us [?] S. Spirea Prunifolia pl. also just imported bears a great quantity of clusters of white blossoms like the Dbl. white Hawthorn.

I suppose Montgomery Place is looking very perfect this fine *leafy* season. I have also been making some little improvements in my own garden—and especially build-

ing a rustic summer house which we call the ''hermitage,'' and which I think is so much in your own taste that I should be heartily glad to show it to you.

Mrs. Downing joins me in the kindest expression of regards to Mrs. Livingston, Mr Barton, & yourself. (in which our young friend Miss Wagner who has just arrived from Charleston begs leave to join). It would give us very great pleasure, my dear Madam, to receive a visit from you all here. I think there are several things in our neighborhood that would interest you.

Mr. Barton has I suppose made good use of this fine growing season in his arboretum.

<div style="text-align:center">Yours most sincerely,
A.J. Downing</div>

<div style="text-align:center">Letter #7
A.J. Downing to Cora L. Barton</div>

Highland Garden
June 17, 1848

I am delighted, My dear Madam, to learn by your very obliging note that the little basket of plants pleased you. I assure you I take as lively an interest in Montgomery Place and feel as proud of it as belonging to this part of the world as I do of the Hudson itself.

Mrs. Livingston and yourself are very kind to send us again this—one of the most agreeable of the invitations of the season—we accept it with great pleasure—and

some time in the latter part of July or end of August— whenever it shall be quite convenient and agreeable to you we shall hope to enjoy your kind hospitality again. I wish also very much to see the improvements—and Mr. Bartons Arboretum. I think that I have imagination enough—being able to carry ten or twenty years *future growth* in my mind when seeing a plant only 1 ft. high— better than most persons—to be able to comprehend & enjoy it.

In the meantime we trust to some impromptu visit from you. I shall find it therefore quite impossible to give any sketch or plan of the ''hermitage'' until you have seen it!

I should be very glad to aid you in the plan of your pit—but perhaps shall need more definite details. What you describe is rather a small greenhouse than a pit.

My neighbor in Westchester, Mr. Ludlow, constructed last season a pit—with double sashes—6 inches apart— the topmost one a few inches only above the surface of the ground, which, without any fire heat, kept Camellias Roses & all the hardier green house plants well through the winter.

A cold pit like this is usually made only 6 ft. wide, 5 or 6 inches above ground in front, & 9 or 10 inches at the back.

What, I imagine, you require, is a sort of *propagating pit*—and I would recommend one the form of which you will easily understand by the section which I send you on the next page.

This is a sort of cheap span-roof building part of

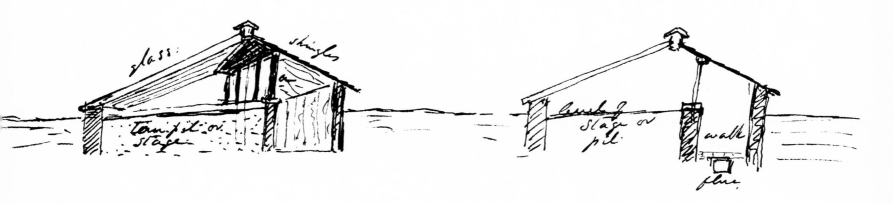

which is *glass* & the other part, viz the roof towards the north *shingled*. Under this roof, which is just high enough to allow a person to walk upright, is the walk. The roof is supported by a line of posts, *a*, which rest on the back wall of the pit or stage. This gives a stage rather wider than the glass, & there is no loss in the walk space occupied, as in most cases. The front of the building should be about a foot above ground, & the roof should rise high enough to allow of space for the back walk. In this country I do not find it of the least importance what the *angle* is for a house of this kind— there is so much sun & light.

If you have a bark[?]-pit the flue may be put under the walk. If you have a stage it might run under the stage & be out of sight and out of the way altogether. The furnace may be quite outside in a little pit 3 or 4 ft square, at one end & a little below the level of the house, besides the back walk it would be well to have 2 little paths running cross-wise—to allow of reaching every part of the stage or pit, thus. A house like this, twenty five feet long, & built so that the pit or stage could be 8 ft. wide ought to be quite large enough for your purposes & may be constructed very cheaply. I suppose wood on your own place is the cheapest fuel—otherwise,

35

I should recommend a small air-tight coal stove with the *polmaise* mode of heating[54]—very cheap & simple, requiring no flue, & the stove might be put at one end of the walk. Do not hesitate to ask any explanations if I am not clear in my meaning—or if you do not like this plan I will suggest another. I shall always be most happy to be of the slightest service in your improvements.

Mrs. Downing begs to be most kindly remembered to all at Montgomery Place. Say to Mr. Barton that I shall be very glad to see him here at any time, & believe me, my dear Madam, truly Your ob[t].

A.J. Downing

Letter #8
A.J. Downing to Thomas P.Barton

Newburgh Oct 29 1849

My dear Sir

Your box of specimens unluckily arrived during my visit in Westchester County & I find them somewhat dried on my return so that my opinion as to the species must not be entirely relied on. I recognise them however as follows:

Nos 1 & 2 Cornus circinata

" 3 " paniculata
" 4 Viburnum acerifolium
" 5 a spirea? I dont recognise it.
" 6 Celastrus scandens
" 7 the common Solanum Dulcamara

I am sorry that I could not reply earlier.

Present us most kind to Mrs Livingston & Mrs Barton. I shall be glad if I can be of any further service & only regret that we are not nearer so as to have a little ''arboriculture'' weekly.

Sincerely yours
A.J. Downing

Letter #9
A.J. Downing to Cora L. Barton

Newburgh Oct. 28 [1850]

My dear Mrs Barton

It gave me very great pleasure to receive your note & to hear again from you all at Montgomery. I assure you I have too much pride and pleasure in the Hudson & too much affection for Montgomery Place to allow the possibility of any diminution of interest in all that belongs to it—because I have had the gratification of seeing the fine places of England. I wish I could explain to you in detail my ideas of treating the river lawn of Montgomery Place economically & beautifully—as I learned in England.

Dont you pass the winter in New York? If I remember rightly I have heard that you have determined to change your winter home.

[54]Heating based on the recirculation of the air in the greenhouse by drawing cold air into the furnace and expelling the heated air into the farthest reaches of the greenhouse. ''Description of the Polmaise Mode of Heating Green-Houses,'' *The Horticulturist,* III (September, 1848), pp. 122-127.

I send Mr Barton *two* notes. I think on the whole Whitely & Thomes[?] is the best collection of rare trees abroad & I am particularly pleased with the botanical knowledge of that firm & its great promptness & punctuality in executing orders. Rivers Nursery stands at the head for fruit trees & roses—with many other fine things. I send by this mail one of W & T's [?] catalogues for Mr Barton.

The best grass for the shade is the *Kentucky blue grass*—2 bushels to the acre.

Mrs Downing & I are so very glad to hear that Mrs. Livingstons health is so much better. Pray give our kindest & most respectful remembrances to her & believe me

Most sincerely yours
A.J. Downing

[ENCLOSURE]

Mr. B.

The large leaved Geranium is called "Flower of the Day"

The small leaved do [geranium] I call "Lady Hardwicke." At Wimpole—Lord H's place—where I stayed last summer—it formed the most superb beds—like a carpet—you can form no idea of it from these drought-starved branches. I brought the cuttings from Wimpole.

cuttings of Double white Pomegranate
" of new palmalid Ivy
" Cotoneaster rotundifolia

for Mr Barton

Letter #10
A.J. Downing to Cora L.Barton
Newburgh Aug 22ᵈ 1851

My dear Mrs Barton

I have just returned from Westchester Co and hasten to respond to your wishes by sending you by Archer & Bostwicks Express this day a little box containing the cuttings of geraniums &c —which I trust will reach you safely.

I'm delighted to be able to add in any way to the riches of Montgomery. But like Mr Barton I am a disciple of *Vattemere*[?] and therefore I shall beg you if you have still those superb plants of the "Triumph of Luxembourg" Rose (which I remember in your garden as I have seen them no where else) to send me a few cuttings at any convenient time by the same express.

Mrs Downing and I are much indebted for the kind and hospitable invitation to Montgomery—where we always go with so much delight. But Mrs Downing insists that the pleasure of receiving Mr Barton & yourself here must be first enjoyed. Mr Barton if I remember rightly promised to bring you here in June—but June came with its roses and its rich foliage & no Mr & Mrs Barton.

Now shall we not say September? I would ask you to come at once, but I leave home early next week for the south & will not be at home till the 8ᵗʰ of Sept. After that I shall write you again asking you to fix some day when you can come to us. I want to show you my *working*

library added to my home since you were here—and possibly there may be some tree on my grounds that may have grown more respectable in Mr Barton's eyes.

This delightful rain puts all us country people in good spirits & I am sure makes Montgomery Place appear very fresh & lovely.

Will you present our kindest remembrances to Mrs Livingston and believe me most truly & faithfully

<div align="center">Your ob^t</div>

A.J. Downing

Highland Gardens.
Newburgh, N. Y. Feb 1st 1845

Bought of **A. J. Downing & Co.**

1 Willow Oak 4/	—	.25
1 large Osage Orange 6/		.75
3 American Cypress $2 (set in bog)		6.00
4 European Larch 4/	—	2.00
2 Liquidamber 4/	—	1.00
1 coffee tree 4/	—	.50
2 Silver Aspen 4/	—	1.00
1 Scotch Elm 4/	—	1.00
2 Red Leaved Beech with a bog 4/		2.00
1 Glaucus Thorn Acacia	—	.50
2 Western Magnolia 8/	—	2.00
2 French Paper Mulberry 8/	—	1.50
1 Sweetbriar tea 4/		.50
2 Strawberry tea leaved 8/	—	2.00
2 Plane 4/	—	1.00
2 Raspberry 3/	—	.75
2 large Purple Californian Currant 4/	—	.76
1 Silver Rose		.50
2 Buffalo Rose 4/	—	1.00
2 Scarlet flg Ribes 4/	—	1.00
2 Weleb do 4/	—	1.00
1 Broad leaved Laburnum		.50
1 Cornelia Cherry		.50
2 English flg Thorn 4/	—	1.00
1 Arbuck		.50
18 American Plants 10/-		3.00
Packing 5 bag box & bag 6/-		3.75
		$37.35
		$37.35

Highland Gardens.

Newburgh, N. Y. *October 28* 1845

Mr. Ella Livingston Bought of **A. J. Downing & Co.**

2 Nisbury 4/ - — 1.00
2 Laburnum 4/ - — 1.00
2 Dt Scarlet Thorn 4/ - — .75
1 Weeping Black Thorn 4/ - — 1.00
2 Privet 4/ - — .75
2 Rose Acacia 3/ - — .75
2 White Lilac 3/ - — .75
1 Strawberry tree 4/ - — 1.00
1 Dt Red Willow 3/ - — .37
1 Syringa 4/ - — .50
1 Fringe tree 4/ - — .50
2 White Rosa Do 4/ - — 1.00
Prck 2 d/ 4/ - — 1.00
Freight Pd 3/ - — 1.00

$11.75

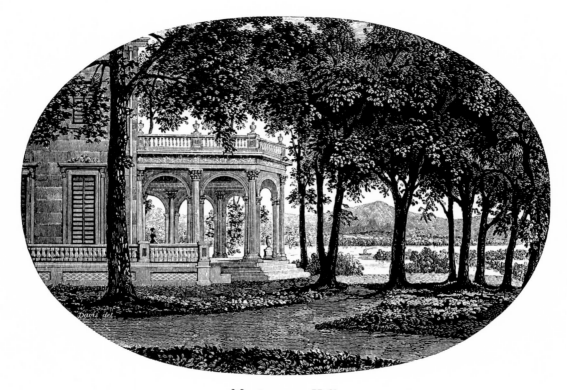

Montgomery Hall

THE Horticulturist,

JOURNAL OF RURAL ART AND RURAL TASTE.

A VISIT TO MONTGOMERY PLACE[55]
By Andrew Jackson Downing

THERE are few persons, among what may be called the travelling class, who know the beauty of the finest American country seats. Many are ignorant of the very existence of those rural gems that embroider the landscape here and there, in the older and wealthier parts of the country. Held in the retirement of private life, they are rarely visited, except by those who enjoy the friendship of their possessors. The annual tourist by the railroad and steamboat, who moves through wood and meadow and river and hill, with the celerity of a rocket, and then fancies he knows the country, is in a state of total ignorance of their many attractions; and those whose taste has not led them to seek this species of pleasure, are equally unconscious of the landscape-gardening beauties that are developing themselves every day, with the advancing prosperity of the country.

It has been our good fortune to know a great number of the finest of these delightful residences, to revel in their beauties, and occasionally to chronicle their charms. If we

[55]This article first appeared without a title in *The Horticulturist, and Journal of Rural Art and Rural Taste,* Vol. II, No. 4 (October, 1847), pp. 153-160.

have not sooner spoken at large of MONTGOMERY PLACE, second as it is to no seat in America, for its combination of attractions, it has been rather that we were silent—like a devout gazer at the marvellous beauty of the Apollo—from excess of enjoyment, than from not deeply feeling all its varied mysteries of pleasure-grounds [sic] and lawns, wood and water.

MONTGOMERY PLACE is one of the superb old seats belonging to the LIVINGSTON family, and situated in that part of Dutchess County bordering on the Hudson. About one hundred miles from New York, the swift river steamers reach this part of the river in six hours; and the guest, who leaves the noisy din of the town in the early morning, finds himself, at a little past noon, plunged amid all the seclusion and the quiet of its leafy groves.

And this *accessible* perfect seclusion is, perhaps, one of the most captivating features in the life of the country gentleman, whose lot is cast on this part of the Hudson. For twenty miles here, on the eastern shore, the banks are nearly a continuous succession of fine seats. The landings are by no means towns, or large villages, with the busy air of trade, but quiet stopping places, serving the convenience of the neighboring residents. Surrounded by extensive pleasure grounds, fine woods or parks, even the adjoining estates are often concealed from that part of the grounds around the house, and but for the broad Hudson, which forms the grand feature in all these varied landscapes—the Hudson always so full of life in its numberless bright sails and steamers—one might fancy himself a thousand miles from all crowded and busy haunts of men.

Around MONTGOMERY PLACE, indeed, this air of quiet and seclusion lurks more bewitchingly than in any other seat whose hospitality we have enjoyed. Whether the charm lies in the deep and mysterious wood, full of the echo of water spirits, that forms the northern boundary, or whether it grows out of a profound feeling of completeness and perfection in foregrounds of old trees, and distances of calm serene mountains, we have not been able to divine; but certain it is that there is a spell in the very air, which is fatal to the energies of a great speculation. It is not, we are sure, the spot for a man to plan campaigns of conquest, and we doubt even whether the scholar, whose ambition it is

> "To scorn delights,
> And live laborious days,"

would not find something in the air of this demesne, so soothing as to dampen the fire of his great purposes, and dispose him to believe that there is more dignity in repose, than merit in action.

There is not wanting something of the charm of historical association here. The estate derives its name from GEN. MONTGOMERY, the hero and martyr of Quebec (whose portrait, among other fine family pictures, adorns the walls of the mansion). MRS. MONTGOMERY, after his lamented death on the heights of Abraham, resided here during the remainder of her life. At her death, she bequeathed it to her brother, the HON. EDWARD LIVINGSTON, our late minister to France. Here this distinguished diplomatist and jurist

passed, in elegant retirement, the leisure intervals of a life largely devoted to the service of the state, and here still reside his family, whose greatest pleasure seems to be to add, if possible, every year, some admirable improvement, or elicit some new charm of its extraordinary natural beauty.

The age of MONTGOMERY PLACE heightens its interest in no ordinary degree. Its richness of foliage, both in natural wood and planted trees, is one of its marked features. Indeed, so great is the variety and intricacy of scenery, caused by the leafy woods, thickets and bosquets, that one may pass days and even weeks here, and not thoroughly explore all its fine points—

> "Milles arbres, de ces lieux ondoyante parure
> Charme de l'odorat, de gout et des regards,
> Elégamment groupés, négligemment épars,
> Se fuyaient, s'approchaient, quelquefois à la vue
> Ouvraient dans la lointain un scene imprévue;
> Ou, tombant jusqu'à terre, et recourbant leurs bras
> Venaient d'un doux obstacle embarrasser leurs pas;
> Ou pendaient sur leur tête en festons de verdure,
> Et de fleurs, en passant, semaient leur chevelure.

> Dirai-je ces forêts d'arbustes, d'arbrisseaux,
> Entrelacant en voûte, en alcove, en berceaux,
> Leurs bras volupteux, et leurs tiges fleuries?"[56]

About four hundred acres comprise the estate called MONTGOMERY PLACE, a very large part of which is devoted to pleasure grounds and ornamental purposes. The ever varied surface affords the finest scope for the numerous roads, drives, and walks, with which it abounds. Even its natural boundaries are admirable. On the west is the Hudson, broken by islands into an outline unusually varied and picturesque. On the north, it is separated from BLITHEWOOD, the adjoining seat, by a wooded valley, in the depths of which runs a broad stream, rich in waterfalls. On the south is a rich oak wood, in the centre of which is a private drive. On the east it touches the post road. Here is the entrance gate, and from it leads a long and stately avenue of trees, like the approach to an old French chateau. Halfway up its length, the lines of planted trees give place to a tall wood, and this again is succeeded by the lawn, which opens in all its stately dignity, with increased effect, after the deeper shadows of this vestibule-like wood. The eye is now caught at once by the fine specimens

[56]A thousand trees, jewels of these undulating scenes,
enchanted one's senses with their fragrance and beauty;
some elegantly grouped, others negligently scattered,
they receded, then drew nearer, revealing to one's vision
unexpected scenes in the distance.
Or, as they touched the ground, and linked their branches,
they created a gentle obstacle, entangling one's step;
as one passed, ornamental chains of
leaves and flowers adorned the hair.
How else can I speak of these forests of bushes and shrubs,
whose voluptuous branches and flowering boles
are entwined like a vault, or a cradle?

of Hemlock, Lime, Ash and Fir, whose proud heads and large trunks form the finest possible accessories to a large and spacious mansion, which is one of the best specimens of our manor houses. Built many years ago, in the most substantial manner, the edifice has been retouched and somewhat enlarged within a few years, and is at present both commodious, and architectural in character.

Without going into any details of the interior, we may call attention to the unique effect of the *pavilion,* thirty feet wide, which forms the north wing of this house. It opens from the library and drawing-room by low windows. Its ribbed roof is supported by a tasteful series of columns and arches, in the style of an Italian arcade. As it is on the north side of the dwelling, its position is always cool in summer; and this coolness is still farther increased by the abundant shade of tall old trees, whose heads cast a pleasant gloom, while their tall trunks allow the eye to feast on the rich landscape spread around it. (See *Frontispiece.)*

To attempt to describe the scenery, which bewitches the eye, as it wanders over the wide expanse to the west from this pavilion, would be but an idle effort to make words express what even the pencil of the painter often fails to copy. As a foreground, imagine a large lawn waving in undulations of soft verdure, varied with fine groups, and margined with rich belts of foliage. Its base is washed by the river, which is here a broad sheet of water lying like a long lake beneath the eye. Wooded banks stretch along its margin. Its bosom is studded with islands, which are set like emeralds on its pale blue bosom. On the opposite shores, more than a mile distant, is seen a rich mingling of woods and cornfields. But the crowning glory of the landscape is the background of mountains. The Kaatskills, as seen from this part of the Hudson, are, it seems to us, more beautiful than any mountain scenery in the middle States. It is not merely that their outline is bold, and that the summit of Roundtop, rising 3000 feet above the surrounding country, gives an air of more grandeur than is usually seen, even in the Highlands; but it is the *colour* which renders the Kaatskills so captivating a feature in the landscape here. Never harsh or cold, like some of our finest hills, nature seems to delight in casting a veil of the softest azure over these mountains—immortalized by the historian of Rip Van Winkle. Morning and noon, the shade only varies from softer to deeper blue. But the hour of sunset is the magical time for the fantasies of the colour-genii of these mountains. Seen at this period, from the terrace or the pavilion of MONTGOMERY PLACE, the eye is filled with wonder at the various dyes that bathe the receding hills—the most distant of which are twenty or thirty miles away. Azure, purple, violet, pale grayish-lilac, and the dim hazy hue of the most distant cloud-rift, are all seen, distinct, yet blending magically into each other in these receding hills. It is a spectacle of rare beauty, and he who loves tones of colour, soft and dreamy as one of the mystical airs of a German maestro, should see the sunset fade into twilight from the seats on this part of the Hudson.

THE MORNING WALK.

Leaving the terrace on the western front, the steps of the visitor, exploring MONTGOMERY PLACE, are naturally directed towards the river bank. A path on the left of the broad lawn leads one to the fanciful rustic-gabled seat, among a growth of locusts at the bottom of the slope. Here commences a long walk, which is the favorite morning ramble of guests. Deeply shaded, winding along the thickly wooded bank, with the refreshing sound of the tide-waves gently dashing against the rocky shores below, or expending themselves on the beach of gray gravel, it curves along the bank for a great distance. Sometimes overhanging cliffs, crested with pines, frown darkly over it; sometimes thick tufts of fern and mossy-carpeted rocks border it, while at various points, vistas or long reaches of the beautiful river scenery burst upon the eye. Half-way along this morning ramble, a rustic seat, placed on a bold little plateau, at the base of a large tree, eighty feet above the water, and fenced about with a rustic barrier, invites you to linger and gaze at the fascinating river landscape here presented. It embraces the distant mountains, a sylvan foreground, and the broad river stretching away for miles, sprinkled with white sails. The *coup-d'oeil* is heightened by its being seen through a dark framework of thick leaves and branches, which open here just sufficiently to show as much as the eye can enjoy or revel in, without change of position.

A little farther on, we reach a flight of rocky steps, leading up to the border of the lawn. At the top of these is a rustic seat with a thatched canopy, curiously built round the trunk of an aged pine.

Passing these steps, the morning walk begins to descend more rapidly toward the river. At the distance of some hundred yards, we find ourselves on the river shore, and on a pretty jutting point of land stands a little *rustic pavilion*, from which a much lower and wider view of the landscape is again enjoyed. Here you find a boat ready for an excursion, if the spirit leads you to reverse the scenery, and behold the leafy banks from the water.

THE WILDERNESS.

Leaving the morning walk, we enter at once into "The Wilderness." This is a large and long wooded valley. It is broad, and much varied in surface, swelling into deep ravines, and spreading into wide hollows. In its lowest depths runs a large stream of water, that has, in portions, all the volume and swiftness of a mountain torrent. But the peculiarity of "The Wilderness," is in the depth and massiveness of its foliage. It is covered with the native growth of trees, thick, dark and shadowy, so that once plunged in its recesses, you can easily imagine yourself in the depths of an old forest, far away from the haunts of civilization. Here and there, rich thickets of the

Kalmia or native Laurel clothe the surface of the ground, and form the richest underwood.

But the Wilderness is by no means savage in the aspect of its beauty; on the contrary, here as elsewhere in this demesne, are evidences, in every improvement, of a fine appreciation of the natural charms of the locality. The whole of this richly wooded valley is threaded with walks, ingeniously and naturally conducted so as to penetrate to all the most interesting points; while a great variety of rustic seats, formed beneath the trees, in deep secluded thickets, by the side of the swift rushing stream, or on some inviting eminence, enables one fully to enjoy them.

There are a couple of miles of these walks, and from the depth and thickness of the wood, and the varied surface of the ground, their intricacy is such that only the family, or those very familiar with their course, are at all able to follow them all with anything like positive certainty as to their destination. Though we have threaded them several seasons, yet our late visit to Montgomery Place found us giving ourselves up to the pleasing perplexity of choosing one at random, and trusting to a lucky guess to bring us out of the wood at the desired point.

Not long after leaving the *rustic pavilion,* on descending by one of the paths that diverges to the left, we reach a charming little covered resting place, in the form of a rustic porch. The roof is prettily thatched with thick green moss. Nestling under a dark canopy of evergreens in the shelter of a rocky fern-covered bank, an hour or two may be whiled away within it, almost unconscious of the passage of time.

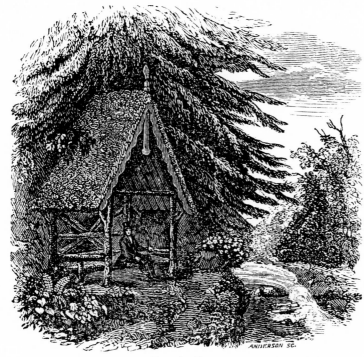

Rustic Seat

THE CATARACT.

But the stranger who enters the depths of this dusky wood by this route, is not long inclined to remain here. His imagination is excited by the not very distant sound of waterfalls.

"Above, below, aerial murmurs swell,
From hanging wood, brown heath and bushy dell;
A thousand gushing rills that shun the light,
Stealing like music on the ear of night."

He takes another path, passes by an airy looking rustic bridge, and plunging for a moment into the thicket, emerges again in full view of the first cataract. Coming from the solemn depths of the woods, he is astonished at the noise and volume of the stream, which here rushes in wild foam and confusion over the rocky fall, forty feet in depth. Ascending a flight of steps made in the precipitous banks of the stream, we have another view, which is scarcely less spirited and picturesque.

This waterfall, beautiful at all seasons, would alone be considered a sufficient attraction to give notoriety to a rural locality in most country neighborhoods. But as if nature had intended to lavish her gifts here, she has, in the course of this valley, given two other cataracts. These are all striking enough to be worthy of the pencil of the artist, and they make this valley a feast of wonders to the lovers of the picturesque.

There is a secret charm which binds us to these haunts of the water spirits. The spot is filled with the music of the falling water. Its echoes pervade the air, and beget a kind of dreamy revery. The memory of the world's toil gradually becomes fainter and fainter, under the spell of the soothing monotone; until at last one begins to doubt the existence of towns and cities, full of busy fellow beings, and to fancy the true happiness of life lies in a more simple existence, where man, the dreamy silence of thick forests, the lulling tones of babbling brooks, and the whole heart of nature, make one sensation, full of quiet harmony and joy.

THE LAKE.

That shadowy path, that steals away so enticingly from the neighborhood of the cataract, leads to a spot of equal, though a different kind of loveliness. Leaving the border of the stream, and following it past one or two distracting points, where other paths, starting out at various angles, seem provokingly to tempt one away from the neighborhood of the water, we suddenly behold, with a feeling of delight, THE LAKE.

Nothing can have a more charming effect than this natural mirror in the bosom of the valley. It is a fine expansion of the same stream, which farther down forms the large cataract. Here it sleeps, as lazily and glassily as if quite incapable of aught but reflecting the beauty of the blue sky, and the snowy clouds, that float over it. On two sides, it is overhung and deeply shaded by the bowery thickets of the surrounding wilderness; on the third is a peninsula, fringed with the

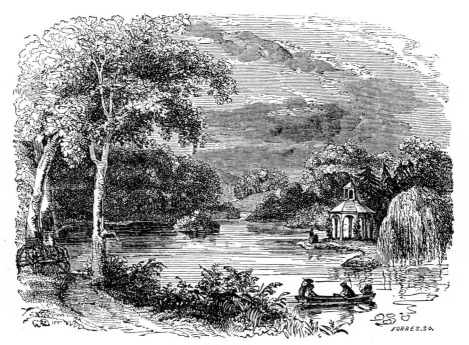

The Lake

graceful willow, and rendered more attractive by a *rustic temple;* while the fourth side is more sunny and open, and permits a peep at the distant azure mountain tops.

This part of the grounds is seen to the most advantage, either toward evening, or in moonlight. Then the effect of contrast in light and shadow is most striking, and the

seclusion and beauty of the spot are more fully enjoyed than at any hour. Then you will most certainly be tempted to leave the curious rustic seat, with its roof wrapped round with a rude entablature like Pluto's crown; and you will take a seat in *Psyche's boat,* on whose prow is poised a giant butterfly, that looks so mysteriously down into the depths below as to

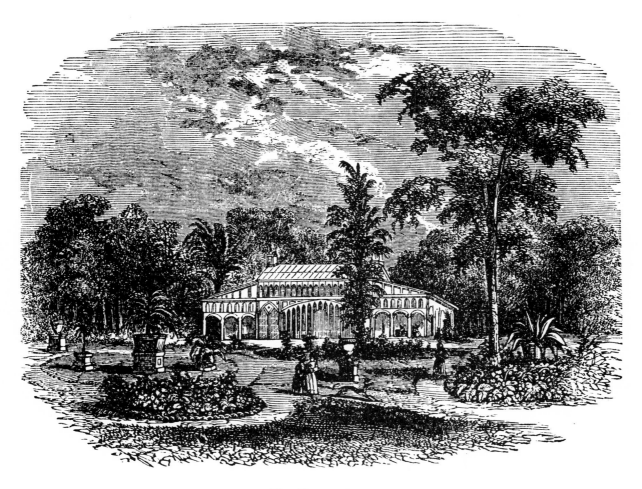

The Conservatory

impress you with a belief that it is the metempsychosis of the spirit of the place, guarding against all unhallowed violation of its purity and solitude.

The peninsula, on the north of the lake, is carpeted with the dry leaves of the thick cedars that cover it, and form so umbrageous a resting place that the sky over it seems absolutely dusky at noon day. On its northern bank is a rude sofa, formed entirely of stone. Here you linger again, to wonder afresh at the novelty and beauty of the *second cascade*. The stream here emerges from a dark thicket, falls about twenty feet, and then rushes away on the side of the peninsula opposite the lake. Although only separated by a short walk and the mass of cedars on the promontory, from the lake itself, yet one cannot be seen from the other; and the lake, so full of the very spirit of repose, is a perfect opposite to this foaming, noisy little waterfall.

Farther up the stream, is another cascade, but leaving that for the present, let us now select a path leading, as near as we can judge, in the direction of the open pleasure grounds near the house. Winding along the sides of the valley, and stretching for a good distance across its broadest part, all the while so deeply immersed, however, in its umbrageous shelter, as scarcely to see the sun, or indeed to feel very certain of our whereabouts, we emerge in the neighborhood of the CONSERVATORY.

This is a large, isolated, glazed structure, designed by MR. CATHERWOOD, to add to the scenic effect of the pleasure grounds. On its northern side are, in summer, arranged the more delicate green-house plants; and in front are groups of large Oranges, Lemons, Citrons, Cape Jasmines, Eugenias, etc., in tubs—plants remarkable for their size and beauty. Passing under neat and tasteful archways of wirework, covered with rare climbers, we enter what is properly

THE FLOWER GARDEN.

How different a scene from the deep sequestered shadows of the Wilderness! Here all is gay and smiling. Bright parterres of brilliant flowers bask in the full daylight, and rich masses of colour seem to revel in the sunshine. The walks are fancifully laid out, so as to form a tasteful whole; the beds are surrounded by low edgings of turf or box, and the whole looks like some rich oriental pattern of carpet or embroidery. In the centre of the garden stands a large vase of the Warwick pattern; others occupy the centres of parterres in the midst of its two main divisions, and at either end is a fanciful light summer-house, or pavilion, of Moresque character. The whole garden is surrounded and shut out from the lawn, by a belt of shrubbery, and above and behind this, rises, like a noble framework, the background of trees of the lawn and the Wilderness. If there is any prettier flower-garden scene than this *ensemble* in the country, we have not yet had the good fortune to behold it.

It must be an industrious sight-seer who could accomplish more than we have here indicated of the beauties of this residence, in a day. Indeed there is enough of exercise for the body, and the enjoyment for the senses in it, for a week. But another morning may be most agreeably passed in a portion

of the estate quite apart from that which has met the eye from any point yet examined. This is

THE DRIVE.

On the southern boundary is an oak wood of about fifty acres. It is totally different in character from the Wilderness on the north, and is a nearly level or slightly undulating surface, well covered with fine Oak, Chestnut, and other timber trees. Through it is laid out the DRIVE; a sylvan route as agreeable for exercise in the carriage, or on horseback, as the "Wilderness," or the "Morning Walk," is for a ramble on foot. It adds no small additional charm to a country place in the eyes of many persons, this secluded and perfectly private drive, entirely within its own limits.

Though MONTGOMERY PLACE itself is old, yet a spirit ever new directs the improvements carried on within it. Among those more worthy of note, we gladly mention an *arboretum*, just commenced on a fine site in the pleasure grounds, set apart and thoroughly prepared for the purpose. Here a scientific arrangement of all the most beautiful hardy trees and shrubs, will interest the student, who looks upon the vegetable kingdom with a more curious eye than the ordinary observer.

The whole extent of the private roads and walks, within the precincts of MONTGOMERY PLACE, is between *five and six miles*. The remarkably natural beauty which it embraces, has been elicited and heightened everywhere, in a tasteful and judicious manner. There are numberless lessons here for the landscape gardener; there are an [sic] hundred points that will delight the artist; there are meditative walks and a thousand suggestive aspects of nature for the poet; and the man of the world, engaged in a feverish pursuit of its gold and glitter, may here taste something of the beauty and refinement of rural life in its highest aspect, and be able afterwards understandingly to wish that

> "One fair asylum from the world *he* knew,
> One chosen seat, that charms with various view.
> Who boasts of more, (believe the serious strain,)
> Sighs for a home, and sighs, alas! in vain.
> Thro' each he roves, the tenant of a day,
> And with the swallow wings the year away."
> ROGERS[57]

[57]Samuel Rogers (1763-1855), an English poet.

Coralie Livingston Barton (1806-1873)

Attributed to Jacques Amans (1801-1888)
(Courtesy of Sleepy Hollow Restorations)

Louise Livingston (1781-1860)

Attributed to Theobold Chartran (1849-1907)
(Courtesy of Sleepy Hollow Restorations)

Sketches of Montgomery Place

by Alexander Jackson Davis

(Notes to the Sketches immediately follow page 72.)

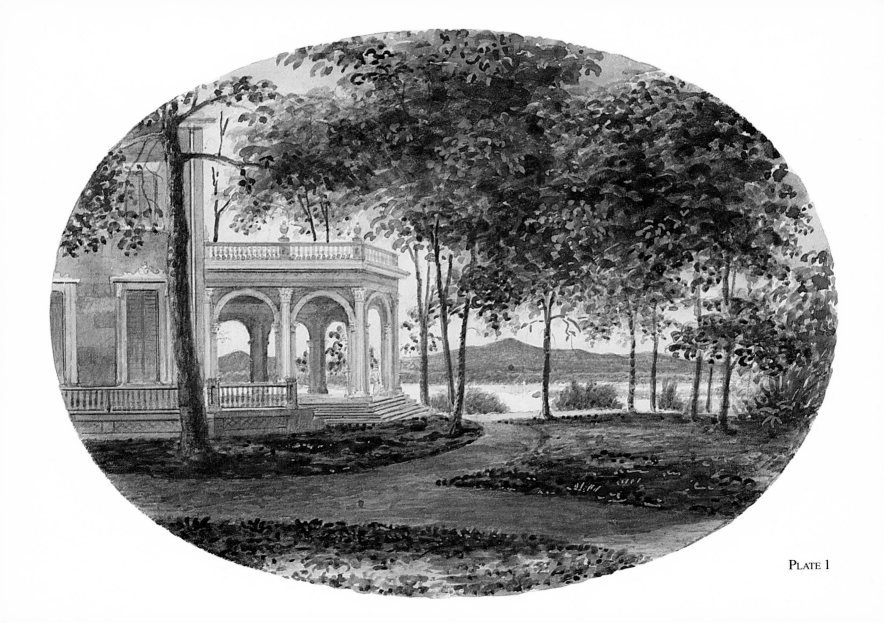

PLATE 1

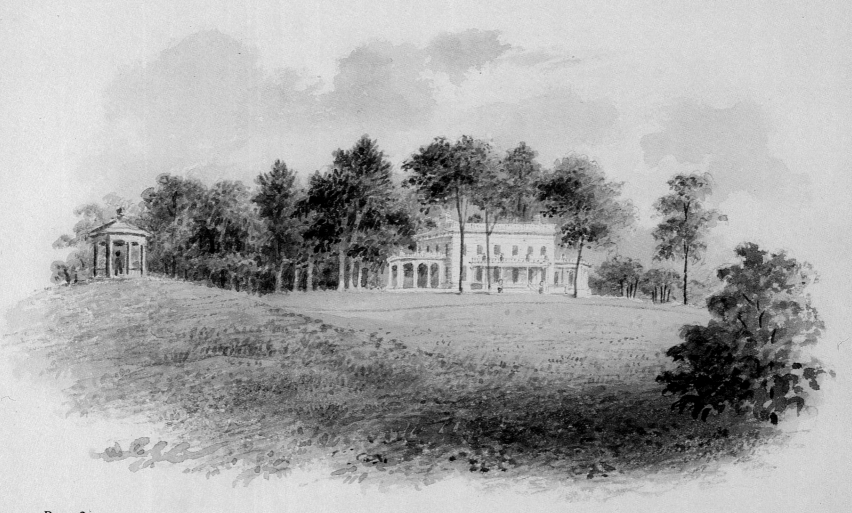

PLATE 2

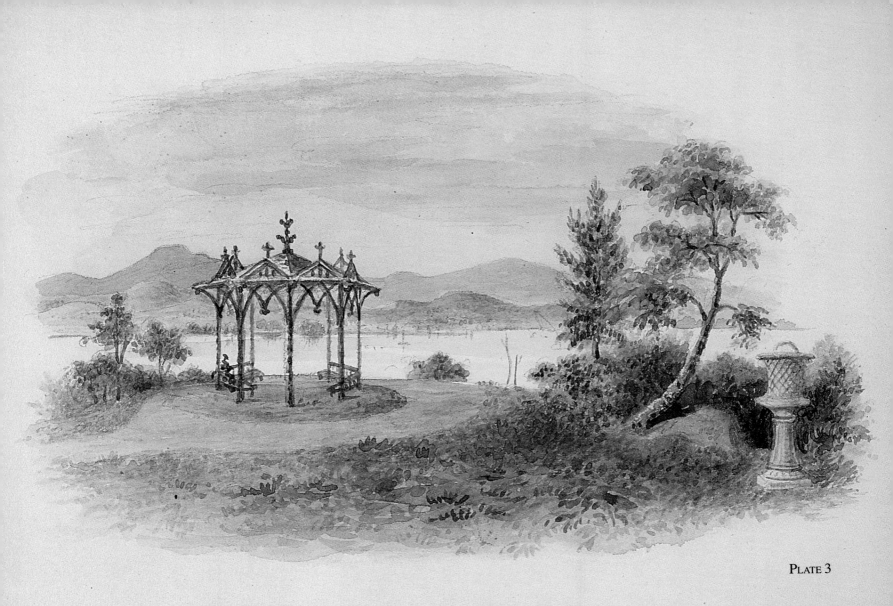

PLATE 3

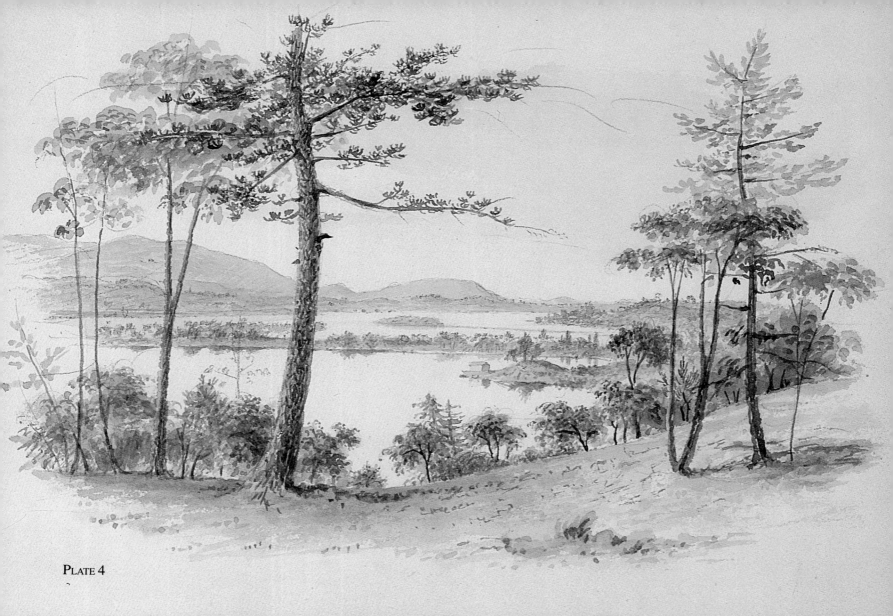

PLATE 4

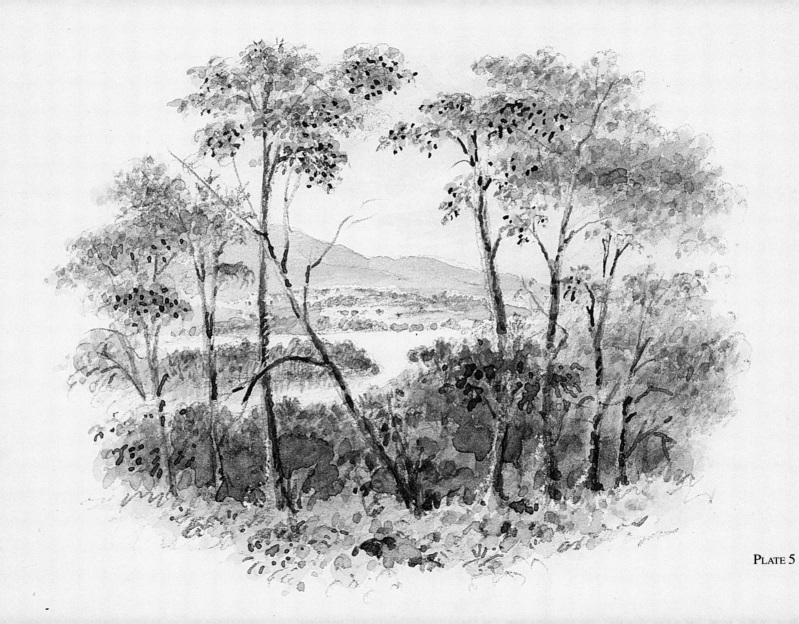

PLATE 5

PLATE 6

Plate 7

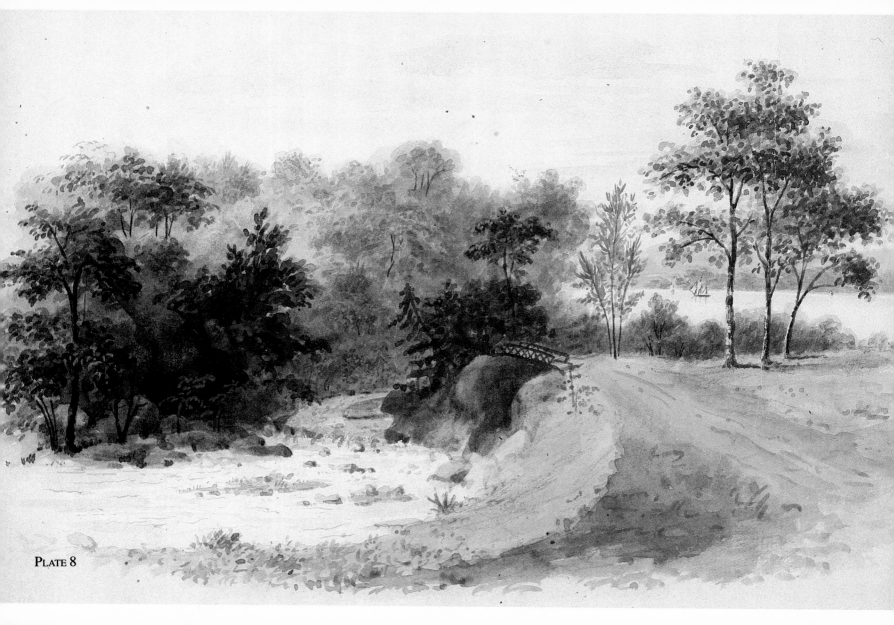

PLATE 8

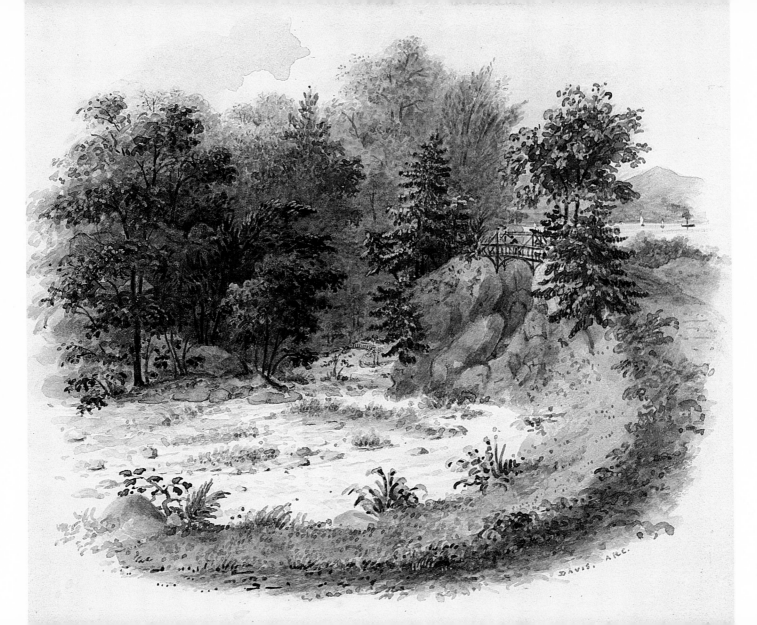

DAVIS, ARC.

PLATE 9

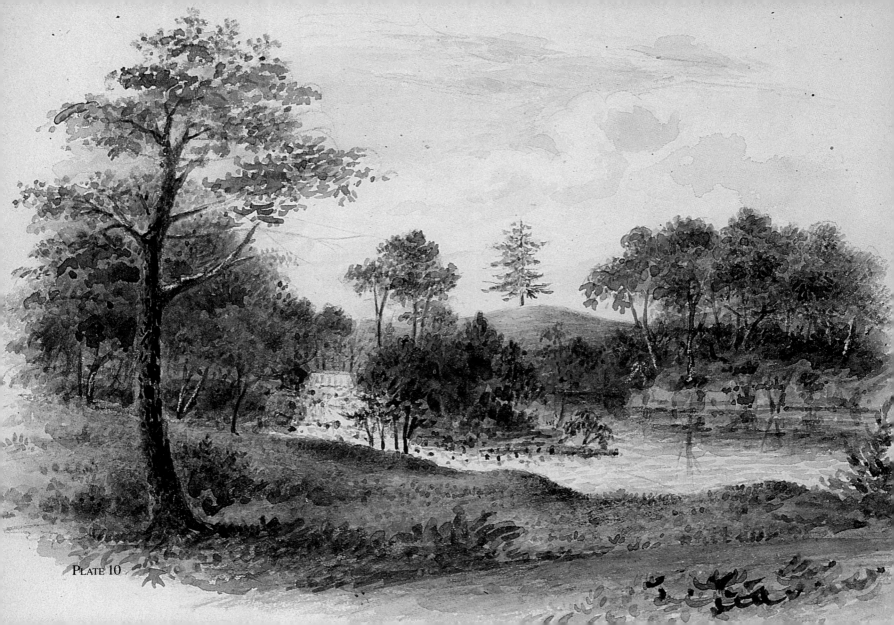

PLATE 10

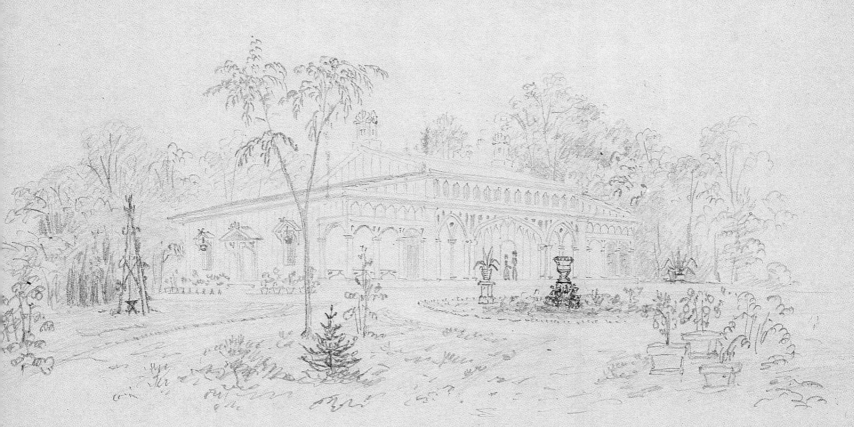

PLATE 11

Plate 12

PLATE 13

Montgomery Place.

9 to 12 inches
Thick.

A.
fill in at A with
a log or window
as at B

B

18

10 ft. side to side.
11 ft. on floor

3 ft.

old roof
or
rock.

old roof of chestnut shingle

5 ← 10 → 5

8

9

9

12

cover with chestnut shingle

slate resting on split
cedar beams
chipped on the end.

Whole seat
2 in. ft.
A.D.

Plate 14

NOTES TO SKETCHES

PLATE 1. *View from Montgomery Place*. The woodcut made from this Davis sketch became the Frontispiece for the October, 1847 issue of *The Horticulturist*. The selection of this view of the house, the north pavilion, illustrates both Downing's and Davis's concern for a smooth transition from the interior of the house to the surrounding landscape. Three years later, in his *Architecture of Country Houses*, Downing remarked that Montgomery Place was the only house in the north where he had seen such a useful and appropriate appendage. The pavilion, designed by A.J. Davis for Mrs. Livingston, gave ''a completeness and significance to a first-rate country house like this; completeness, since it affords something more than a veranda, viz. a *room in the open air*, the greatest luxury in a warm summer; significance, since it tells the story of a desideratum growing out of our climate, architecturally and fittingly supplied.'' (Courtesy of A.J. Davis Collection 2, Avery 1-14.)

PLATE 2. *Montgomery Place*. Had the nineteenth-century visitor to Montgomery Place stopped at the shore seat on ''The Morning Walk,'' and looked back to the east, he or she would have seen this view of the west facade of Montgomery Place. The 1841-1844 classical additions of north pavilion, south wing and west terrace designed by A.J. Davis are clearly visible. The small classical temple on the small knoll to the right repeats the use of classical elements seen on the house. (Courtesy of Franklin D. Roosevelt Library, Hyde Park, New York.)

PLATE 3. *Montgomery Place - Shore Seat*. This probably represents the "bold rustic seat with rustic balustrade" on the Morning Walk. (A.J. Downing to A.J. Davis, July 26, 1847.) Davis's sketches of rustic seats in landscapes can be very deceiving. He was as capable of drawing what he thought a rustic seat should look like as he was of drawing the actual seat. Similarly, in his finished sketches he might eliminate existing trees or shrubs, even structures, which interfered with the vista he wished to illustrate. (Courtesy of Franklin D. Roosevelt Library.)

PLATES 4. & 5. *River Vista*. Downing specifically requested that Davis sketch the view from the shore seat, looking to the northwest. Both these drawings fit Downing's description of the vista from this point on the Morning Walk: "It embraces the distant mountains, a sylvan foreground, and the broad river stretching away for miles, sprinkled with white sails." The untitled sketch at Hyde Park (PLATE 4) appears to be the original drawing from which Davis made the more finished version "from Montgomery Place looking up river," at the Avery (PLATE 5). (PLATE 4 courtesy of Franklin D. Roosevelt Library.) (PLATE 5 courtesy of A.J. Davis Collection 2, Avery 1-14.)

PLATES 6. & 7. *The Cataract*. The visitor, leaving the Morning Walk, was drawn deeper and deeper into "The Wilderness," enticed by the sound of the Saw Kill's rushing water: "Coming from the solemn depths of the wood, he is astonished at the noise and volume of the stream, which here rushes in wild foam and confusion over a rocky fall, forty feet in depth." Davis depicted the "Cataract" from the northern, Blithewood shore, looking across the Saw Kill toward Montgomery Place. Again, two versions survive: the initial rough sketch of a trail leading up to a rustic temple overlooking the Cataract (PLATE 6), and a finished version of the same scene (PLATE 7). The finished version served as the model for the illustration of the Cataract that appeared in the 1849 edition of Downing's *Landscape Gardening*. (PLATE 6 courtesy of Franklin D. Roosevelt Library.) (PLATE 7 courtesy of A.J. Davis Collection 2, Avery 2-6.)

PLATES 8. & 9. *View in Grounds at Blithewood. Seat of Robt. Donaldson. 1840.* Like the previous two drawings, these depict the joint border of Montgomery Place and Blithewood, the Saw Kill. They show the top of the Cataract, looking downstream toward an island at the base of the falls. The bridge on the right leads to the site of the temple shown in PLATES 6 and 7. Davis drew these views in 1840, as Robert Donaldson and Louise Livingston negotiated with John C. Cruger to purchase the lands on both sides of the Saw Kill and, most important, the water rights. Cruger had attempted to interest a Birmingham industrialist in this Saw Kill site, but was unsuccessful. Donaldson wished to acquire the property to prevent industrial development on his southern doorstep, and to finish up his pleasure grounds: "If we buy the stream …our pleasure grounds extend to the creek from the Cataract to the River—& a lake for fish formed, with ornamental waterfalls—which would render the places all that could be desired." (Robert Donaldson to Louise Livingston, December 16, 1840, Sleepy Hollow Restorations.)

PLATE 8 is the original sketch, showing a rough bridge joining the outcrop of rock to the main shore line. The second sketch is both more finished and more romanticized. The simple rough bridge of the earlier sketch is now a more elaborate suspension bridge. The small trees to the right of the bridge appear fully leaved and picturesque. A small bridge crosses from the island to Montgomery Place. (Courtesy of A.J. Davis Collection 2, Avery 2-12.)

PLATE 10. *The Lake*. Davis drew several views of ''The Lake.'' The view used in *The Horticulturist* is from the eastern shore looking to the northwest. The pavilion or temple is clearly visible on a peninsula of land on the right side of the engraving. Here we see a second, very different view of the lake, sketched from the Blithewood side of the Saw Kill. The upper cataract, smaller than that shown in PLATES 6 & 7, appears to the left of the picture, with the peninsula in the center and the lake to the right.

This view more accurately captures the dual nature of the setting, as described by Downing: ''The stream here emerges from a dark thicket, falls about twenty feet, and then rushes away on the side of the peninsula opposite the lake. Although only separated by a short walk and the mass of cedars on the promontory, from the lake itself, yet one cannot be seen from the other; and the lake, so full of the spirit of repose, is a perfect opposite to this foaming, noisy little waterfall.'' (Courtesy of Franklin D. Roosevelt Library.)

PLATE 11. *The Conservatory*. The visitor to the Wilderness and the Lake emerged from the forest, leaving behind the natural beauty of the Saw Kill Valley. He now entered the formal grounds, centered on a gothic conservatory designed by Frederick Catherwood in 1839. *The Horticulturist* woodcut of the conservatory is the view from the west. This second view, from the northwest, represents the conservatory as seen on emerging from the ''Wilderness.''

The conservatory and adjacent flower gardens were the special domain of Cora Livingston Barton. In his *Landscape Gardening* (1849), Downing observed: ''In a part of the lawn, near the house, yet so surrounded by a dark setting of trees and shrubs as to form a rich picture by itself, is one of the most perfect flower gardens in the country, laid out in the arabesque manner, and glowing with masses of the gayest colors—each bed being composed wholly of a single hue.'' (Courtesy of A.J. Davis Collection 2, Avery 1-7.)

PLATE 12. *Garden Structure, Architectural*. Downing's description of his stroll through the grounds of Montgomery Place is filled with references to temples, rustic seats and pavilions. Downing differentiated between two distinct kinds of landscape temples or seats. The first were the *architectural*, those "formed after artist-like designs, of stone or wood, in Grecian, Gothic, or other forms...." These architectural seats belonged "in proximity of elegant and decorated buildings where all around has a polished air." (Downing, *Landscape Gardening*, 6th ed., pp. 392-393.) The small temple in PLATE 2 is an example of this architectural form.

Cora L. Barton asked Davis to help her design a tool house for her husband in the 1840s. She was interested in a formal architectural design, not a rustic shed: "The Building ought not to be more than fourteen feet. An octagon or circle would be best adapted to the position....The building is to have [——] planted round it but we want no rustic work. It would look better with steps....how would a partition through the octagon be, enclosing part of the building for the tools, & leaving the five front arches open...? As the surrounding trees are very large the building ought to be *lofty* not to look *dumpish*." (Cora Livingston Barton to A.J. Davis, August 14, 1863, A.J. Davis Collection 2, Avery 1-3.)

This fourteen foot, octagonal temple may be Davis's response to Cora's request. We do not know if this temple/tool house was ever built. (Courtesy of Sleepy Hollow Restorations.)

PLATE 13. *Rustic Seat*. Downing preferred to see the *rustic* style of seat, "formed out of trunks and branches of trees, roots, etc., in their natural forms" on "distant wooded parts or walks," removed from the formality of the country residence. Here, "the nature of the materials employed and the simple manner of their construction, appear but one remove from natural forms," keeping them in harmony with their settings. (Downing, *Landscape Gardening*, 6th ed., p. 393.) Davis's design for a shore seat at Montgomery Place perfectly illustrates this use of natural materials to create a picturesque vantage point from which to watch the river. If it was ever built, this seat probably occupied an overlook on the lower river walk, out of sight of the house. (The Metropolitan Musem of Art, Harris Brisbane Dick Fund, 1924. [24.66.1052])

PLATE 14. *Garden Arch*. Cora Livingston Barton lavished her attention on the formal garden near Frederick Catherwood's gothic-style conservatory. She turned to Davis to design garden arbors to support the roses and other climbing plants for which her garden became famous. In this design, Davis repeated the gothic arch which dominated the facade of Catherwood's conservatory. (See PLATE 11.) Davis embellished the corners of the triangular arbor with the ornate initials "C" and "L," for Cora Livingston. We do not know if this particular arbor was ever constructed, but arbors like this, "overgrown with Aristolochia sipho, the Dutchman's pipe," added greatly to the picturesque charm of Montgomery Place. (Courtesy of Sleepy Hollow Restorations.)

Andrew Jackson Downing (1815-1852)

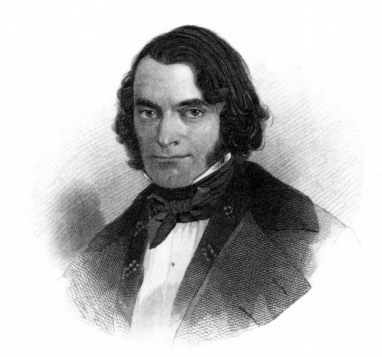

J. Halpin, sc.

ANDREW JACKSON DOWNING (1815-1852)
BIOGRAPHICAL NOTE

Andrew Jackson Downing was born in Newburgh, New York on October 31, 1815. His father, Samuel Downing, had been a wheelwright in Massachusetts but moved to New York in 1800, finally settling in Newburgh in 1801. Here he set up a commercial nursery. Downing was educated at an academy in nearby Montgomery, New York. He left school at the age of sixteen and entered the family nursery business, now run by his brother Charles. The partnership of "C. and A.J. Downing" lasted until Charles set up a separate establishment in 1837. Andrew then became the sole proprietor of A.J. Downing & Co. Shortly after this, Downing married Caroline de Windt of Fishkill, a member of a prominent Hudson River family and great-niece to former president John Quincy Adams.

Downing acquired his practical knowledge of plants and gardening through the family nursery business. His interest in the theory of landscape design and the development of an appropriate American style of landscape design and rural architecture grew out of his extensive readings of the principal English landscape architects of the late-eighteenth and early-nineteenth centuries. He took their ideas, simplified them, and became the great articulator in America for the mid-nineteenth century Romantic school of landscape architecture.

He promoted the "picturesque" style, one based on irregular surfaces, contrasting shapes and the interplay of light and shadow, over the "classical" style which emphasized regularity and balance. At the same time, Downing's artistic sense and his appreciation for the varied nature of the American landscape made him emphasize the position of the house to maximize the aesthetic possibilities of its location. Downing knew that his American audience preferred to use native materials, especially wood, appreciated functionality of design over aesthetics, and worked with limited budgets. He took account of these American prejudices in his designs and successfully educated his audience to the aesthetic qualities of landscape design and architecture which could be achieved at reasonable expense.

This work of educating the taste of the American public was not accomplished through the A.J. Downing & Co. nursery. Although Downing continued in the nursery business for nearly ten years, he left the actual supervision to an associate. Downing concentrated his energies on writing.

In 1841, Downing published the first major American work on landscape design and rural architecture: *A Treatise on the Theory and Practice of Landscape Gardening, Adapted to North America; with a View to the Improvement of Country*

Residences. Comprising Historical Notices and General Principles of the Art, Directions for Laying Out Grounds and Arranging Plantations, the Description and Cultivation of Hardy Trees, Decorative Accompaniments of the House and Grounds, The Formation of Pieces of Artificial Water, Flower Gardens, etc. with Remarks on Rural Architecture. Over the next eleven years, Downing revised and enlarged this work several times, putting out three revised editions before his death in 1852. Additional fifth, sixth, seventh and eighth editions were published by 1875.

Downing followed up on his enormous popularity with *Cottage Residences; or a Series of Designs for Rural Cottages and Cottage Villas, and their Gardens and Grounds. Adapted to North America* (1842) in which he applied the principles articulated in *Landscape Gardening* to smaller rural dwellings. He argued against the use of the Greek Revival style, the miniature white Greek temples which increasingly dotted the countryside, in favor of irregular Gothic and Italianate "cottages," painted in subtle earth tones to blend into the landscape.

In 1846 A. J. Downing became the editor of America's first monthly journal devoted to horticultural issues and the "rural arts." As the editor of *The Horticulturist, and Journal of Rural Art and Rural Taste,* he wrote monthly essays on country matters, answered readers' questions, and presented information on new varieties of plants and technological innovations. His expertise on questions of rural art and taste had been established by his first two books. The 1845 publication, with his brother Charles, of *The Fruits and Fruit*

Trees of America established Downing as a leading figure in commercial agriculture as well.

In the winter of 1846-47, Downing sold out his interest in the nursery to devote himself to writing, and to his work as America's first professional landscape architect. He became increasingly interested in rural architecture, working with George Wightwick on *Additional Notes and Hints to Persons about Buildings in this Country* (1849), and preparing his own full scale work *The Architecture of Country Houses; including Designs for Cottages, Farm-Houses, and Villas, with Remarks on Interiors, Furniture, and the Best Modes of Warming and Ventilating* (1850).

The Architecture of Country Houses, like his earlier publications, was filled with illustrations aimed at the homeowner, rather than the professional builder. This distinguished his presentation from earlier builders' guides. He included perspective views with a landscaped setting for each house, in addition to the more traditional elevation and floor plan. Downing had no architectural training himself, so he turned to other architects to translate his rudely sketched concepts into useable architectural designs. Alexander Jackson Davis, a New York City architect, was one of his most frequent collaborators for illustrations.

As Downing's interest turned increasingly toward architecture proper, rather than landscape design, he looked for a trained architect to take into partnership. Failing to find a suitable candidate in New York, Downing went to England in 1850. Here he saw for the first time some of the great examples of landscape design he had previously only read about. More

important, he met young architect Calvert Vaux[58] and convinced him to come back to the United States as his partner.

In the spring of 1851, the new firm of Downing and Vaux received a commission to design a landscape park in Washington, D.C. for the grounds adjoining the Capitol, the White House and the Smithsonian Institution. Work on this plan was cut short when Downing died as a result of the tragic fire aboard the steamboat *Henry Clay* in the Hudson River off Riverdale, New York on July 28, 1852. A strong swimmer, he was pulled under while trying to save a family friend.

The fire aboard the *Henry Clay* abruptly ended the highly successful career of America's first professional landscape architect. However, Andrew Jackson Downing had left an indelible impression on the American countryside and paved the way for an entire generation of landscape architects.

[58]Calvert Vaux (1824-1895) remained in the United States following Downing's death in 1852. He successfully established himself as an architect in the picturesque style favored by Downing. He published his own house-pattern book, *Villas and Cottages. A Series of Designs Prepared for Execution in the United States* (New York: Harper & Brothers, Publishers, 1857) in which he included several Downing and Vaux designs. He subsequently went on to work with Frederick Law Olmsted (1822-1903) on the design for New York's Central Park.

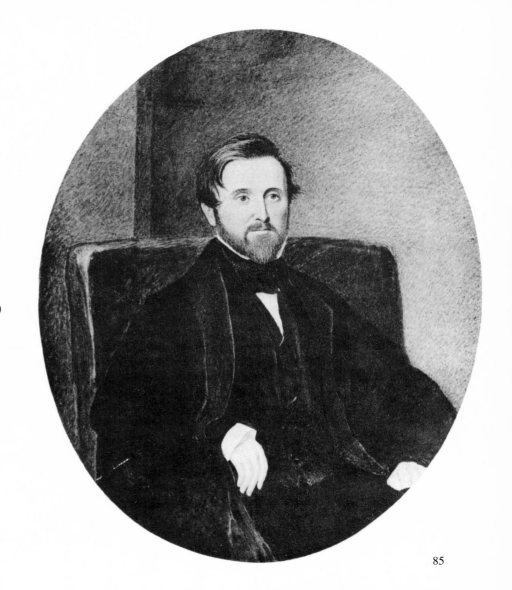

Alexander Jackson Davis (1803-1892)

By George Freeman
(Courtesy of Avery Architectural Library)

ALEXANDER JACKSON DAVIS (1803-1892)
BIOGRAPHICAL NOTE

Alexander Jackson Davis was born in New York City on July 24, 1803, the son of Cornelius Davis and Julia Jackson. His father, a successful publisher, hoped that Alexander would follow the same trade. Alexander, however, showed an early artistic capability. In his mid-teens, he went to work in his half-brother's print shop in Alexandria, Virginia, remaining over five years. At the age of twenty, he returned to New York, this time intent on following his own interest in art. He came under the tutelage of John Trumbull (1756-1843) who encouraged him to pursue a career in architecture.

Davis's artistic forte, skilled draftsmanship and a flair for watercolors would be especially appropriate to his chosen occupation, that of "architectural composer." While he studied as an apprentice designer in the offices of Josiah Brady in 1826-1827, he made a series of architectural and perspective drawings of the principal public buildings in New York. Working as a lithographer, several of his views were published in *The New-York Mirror* in 1827-1829. In 1827 he opened an office as an architectural draftsman with architect James Eddy, who had recently come to New York from Boston. Eddy and others, including Trumbull, encouraged Davis to spend the next two winters in Boston, making perspective views of the chief public buildings and private residences in the area.

Up until this time Davis was still known primarily for his skill as a lithographer, not as an architect. This changed with his 1828 design of a Greek Revival country house for poet James A. Hillhouse. The design so impressed Ithiel Town (1784-1844), one of New York's most respected architects and a confirmed adherent to the Greek Revival style, that he offered Davis a partnership. This partnership provided Davis with a highly skilled mentor in architecture, one who owned the most impressive architectural library in the United States at the time. The partnership of Town and Davis lasted six years (1829-1835), then was revived for a brief period in 1842-1843. Town and Davis designed several important public buildings, including the New York Custom House and the capitols of North Carolina and Indiana.

The partnership with Ithiel Town gave Davis ample opportunity to work in the Greek Revival style which dominated American architecture in the 1830s. However, as Davis continued his personal studies in his partner's private library, he became increasingly enamoured of other revival styles, the Gothic, Italianate, Swiss, and English Tudor, which he felt were far more appropriate for country residences. Overall, Davis had far more diverse tastes than Town, tastes which he would indulge following the dissolution of Town and Davis in 1835.

Alexander J. Davis now began working on his only published book, *Rural Residences*.[59] Originally conceived as the first of a series of publications, Davis and his supporters[60] perceived this collection of designs as a way "of seeing a better taste prevail in the Rural Architecture of this country." In this work, Davis attacked "the bald and uninteresting aspect of our houses," and praised the "picturesque Cottages and Villas of England." He found the Greek Revival style, currently so fashionable, particularly inappropriate for country residences. In its place he proposed the "English collegiate" or Gothic style: "It admits of greater variety both of plan and outline;—is susceptible of additions from time to time, while its bay windows, oriels, turrets, and chimney shafts, give a pictorial effect to the elevation."[61]

The eight designs presented in *Rural Residences* presaged the triumph of picturesque Gothic cottages and Italianate villas over Greek temples as the preferred style in country houses from the 1840s through the Civil War. They also led to a natural collaboration between Davis and another young champion of the picturesque in America, Andrew Jackson Downing. In 1838 Downing began looking for someone who could illustrate the principles of landscape design that he had culled from the great English landscape architects, principles that he would fully articulate three years later in his *Treatise on the Theory and Practice of Landscape Gardening*. Robert Donaldson had used Downing as a landscape architect for his Hudson River properties. He saw that Downing was attempting to put into words the very concepts that Davis already had so brilliantly presented in pictures in his *Rural Residences*. He introduced the two men, beginning a collaboration which lasted until Downing's death in 1852. Throughout these years, Davis was Downing's favorite illustrator, not only for perspective views of proposed cottages and villas, but also for his skilled renderings of romantic vistas, garden seats, and landscapes which Davis successfully translated into woodcut engravings. Davis's woodcuts can be found throughout Downing's published works.

Davis became one of America's most successful mid-nineteenth century architects, designing both public buildings and private residences. He pioneered the use of the Gothic in domestic architecture, so well represented in "The Knoll," now known as Lyndhurst in Tarrytown, New York, which he designed for William Paulding in 1838, and expanded for George Merritt in 1865. His design of a Gothic gate-house

[59]Alexander Jackson Davis, Esq., and other architects, *Rural Residences, Etc. Consisting of Designs, Original and Selected, for Cottages, Farm-Houses, Villas, and Village Churches: with Brief Explanations, Estimates, and a Specification of Materials, Construction, Etc.* (New York, 1837).

[60]James A. Hillhouse, the poet for whom Davis had designed a Greek

Revival style country home in 1828, and Robert Donaldson, a North Carolinian for whom Davis designed a series of country estates on the shores of the Hudson River. Design «3 in *Rural Residences*, "Villa in the English Collegiate Style" was drawn for Donaldson, although never built.

[61]Davis, *Rural Residences*, preface.

(1836) for Robert Donaldson's Blithewood in Barrytown, New York defined the Gothic style in cottage architecture with its board-and-batten siding, diamond-shaped window panes, and high chimneys to emphasize the vertical. Yet he also worked in the Classical style, seen first in Hillhouse's mansion in 1828, and later in the alterations he made to Louise Livingston's Montgomery Place in 1841-1844, and again in 1863.

Between 1852 and 1870 Davis worked with Llewellyn P. Haskell in the development of Llewellyn Park in West Orange, New Jersey. This was the first planned suburban development in the United States, and displayed to the fullest the use of the picturesque in landscape and architectural design. Here all the revival styles so favored by the Romantic movement in America were placed in a picturesque landscape with varied vistas, hidden garden seats, and wandering trails. Davis, who married Margaret Beale in 1853, built his own Gothic home "Wildmont" in Llewellyn Park in 1856.

The revival styles championed by Davis gradually fell from favor in the 1860s and a more flamboyant mixture of stylistic elements gained ascendency with the industrial giants of the post-Civil War era. Davis retired to Wildmont in the 1870s. Although he had pioneered the introduction of new styles in the 1840s, he could not make the transition in the 1870s. The styles he had so successfully popularized were now passé, and he could not work in the new architectural vocabulary.

BIBLIOGRAPHY

Andrew Jackson Downing's Works which mention Montgomery Place.

Downing, Andrew Jackson. *The Architecture of Country Houses*.... New York: D. Appleton & Co., 1850.

—. "Hints to Rural Improvers." *The Horticulturist, and Journal of Rural Art and Rural Taste* III (July 1848).

—. *A Treatise on the Theory and Practice of Landscape Gardening Adapted to North America...With Remarks on Rural Architecture*. New York: Wiley & Putnam, 1841.

—. *A Treatise on the Theory and Practice of Landscape Gardening Adapted to North America...With Remarks on Rural Architecture*. 2nd rev. ed. New York: Wiley & Putnam, 1844.

—. *A Treatise on the Theory and Practice of Landscape Gardening Adapted to North America...With Remarks on Rural Architecture*. 4th rev. ed. New York: George P. Putnam, 1849.

—. *A Treatise on the Theory and Practice of Landscape Gardening Adapted to North America...With Remarks on Rural Architecture*. 6th ed. With a Supplement by Henry Winthrop Sargent. New York: A.O. Moore & Co., 1859.

—. "A Visit to Montgomery Place." *The Horticulturist, and Journal of Rural Art and Rural Taste* II (October 1847).

Other Nineteenth Century References to Montgomery Place.

Ehlers, H[ans] J[acob]. *Defence Against Abuse and Slander, with Some Strictures on Mr. Downing's Book on Landscape Gardening*. New York: W. C. Bryant & Co., 1852.

Eliot, Charles. "Six Old American Country Seats. V. Montgomery Place." *Garden and Forest* (March 19, 1890).

Lamb, Martha J. *The Homes of America*. New York: D. Appleton & Co., 1879.

Lossing, Benson J. *The Hudson, from the Wilderness to the Sea*. Troy, N.Y.: H. B. Nims, & Co., 1866.

Milbert, Jacques Gerard. *Picturesque Itinerary of the Hudson River and the Peripheral Parts of North America.* Translated from the French and Annotated by Constance D. Sherman. Ridgewood, N.J.: The Gregg Press, 1968.

J.D.S. "A Visit to Montgomery Place." *The New-York Mirror: A Weekly Journal of Literature and Fine Arts* XVII (February 8, 1840).

"Visits to Country Places. No. 6. Around New York." *The Horticulturist, and Journal of Rural Art and Rural Taste* XII (1857).

Twentieth Century References to Montgomery Place, Andrew Jackson Downing and Alexander Jackson Davis.

Davies, Jane B. "Davis, Alexander Jackson," *MacMillan Encyclopedia of Architects.* Adolf K. Placzek, ed. New York: The Free Press, 1982.

—. "'We Can't Get On Without You' Letters to Alexander J. Davis, Architect." *Columbia Library Columns* XVI (November 1966).

Delafield, Anita [Mrs. John White Delafield]. "Montgomery Place, the home of Major and Mrs. John White Delafield."*Antiques* XCI (1967).

Delafield, John Ross. "Montgomery Place, Barrytown, New York." *American Architect* CXXXII (1927).

—. "Montgomery Place." *Yearbook, Dutchess County Historical Society* XIV (1929).

—. "Montgomery Place." *New York History* XX (1939).

Eberlein, Harold Donaldson, and Hubbard, Cortland Van Dyke. *Historic Houses of the Hudson River Valley.* New York: Architectural Book Publishing Co., 1942.

Goode, Jeanne, "American Pastoral: The Landscapes of A.J. Downing." *Garden (1987).*

Great Georgian Houses of America. vol 2. New York: Scribner Press, 1937.

Major, Judith K. "The Downing Letters." *Landscape Architecture* LXXVI (1986).

Newton. Roger Hale, *Town & Davis Architects, Pioneers in American Revivalist Architecture l812-1870....* New York: Columbia University Press, 1942.

Reynolds, Helen Wilkinson. *Dutchess County Doorways and Other Examples of Period Work in Wood, 1730-1830....* Photography by Margaret DeM. Brown. New York: William Farquar Payson, 1931.

Spingarn, J[oel] E[lias]. "Henry Winthrop Sargent and the Early History of Landscape Gardening and Ornamental Horticulture in Dutchess County, New York." *Yearbook, Dutchess County Historical Society* XXII (1937).

—. "Henry Winthrop Sargent and the Landscape Tradition at Wodenethe...." *Landscape Architecture* XXIX (1938).

Tatum, George Bishop, "Andrew Jackson Downing: Arbiter of American Taste, 1815-1852." Ph.D. dissertation. Princeton University, 1949.

—. Introduction to *The Architecture of Country Houses*, by Andrew Jackson Downing, 1850. Reprint. New York: Da Capo Press, 1968.

Yarnell, Sophia. "Montgomery Place, an American Scene, Barrytown, New York." *Country Life & The Sportsman* LXXVI (1939).

Zukowsky, John and Stimson, Robbe Pierce. *Hudson River Villas*. New York: Rizzoli, 1985.

Acknowledgments

With a special note of appreciation to J. Dennis Delafield for permitting me to go through the Edward Livingston Papers at Montgomery Place before they were removed to Princeton University; to William Joyce and the staff of Rare Books and Special Collections, Princeton University for permitting me to continue my research in the Edward Livingston Papers; and to Jane B. Davies for her meticulous research to locate and identify all available sources relating to A.J. Davis and his work at Montgomery Place.

About the Editor

Jacquetta M. Haley was born in upstate New York and spent her childhood summer vacations visiting historic houses and sites throughout New York State with her family. This awakened an abiding interest in history which was further strengthened during her undergraduate work at Wells College. She received a Ph.D. in American History from SUNY Binghamton in 1976. Ms. Haley remembered her early love of historic sites and currently works as the Director of Research for Sleepy Hollow Restorations.

INDEX

PLEASURE GROUNDS